FRIDA KAHLO
A Modern Master

Terri Hardin

NEW LINE BOOKS

Fax: (888) 719-7723
e-mail: info@newlinebooks.com

Printed and bound in Singapore

ISBN 1-59764-089-1

Visit us on the web!
www.newlinebooks.com

Author: Terri Hardin

Publisher: Robert M. Tod
Editorial Director: Elizabeth Loonan
Book Designer: Mark Weinberg
Senior Editor: Cynthia Sternau
Project Editor: Ann Kirby
Photo Editor: Edward Douglas
Picture Reseachers: Heather Weigel, Laura Wyss
Production Coordinator: Annie Kaufmann
Desktop Associate: Paul Kachur
Typesetting: Command-O Design

CONTENTS

INTRODUCTION

Frida Kahlo (1907–54) was an artist of inarguable talent. She was the envy of Pablo Picasso, who said of her work, "Neither Derain . . . nor I can paint a head the way Frida Kahlo does." She was exalted by André Breton, who claimed her for his Surrealist movement and wrote the catalog for her first one-woman show. Her painting, *The Frame* (c. 1938), was the first work of a Latin-American artist to be purchased by the Louvre.

Diego Rivera, the great Mexican muralist and Kahlo's husband, was the first to recognize the originality and the power of her art. In his 1943 essay, "Frida Kahlo and Mexico," Rivera said that "the work of Frida Kahlo shines like a diamond in the midst of many inferior jewels. . . . Recurring self-portraits, which are never alike and increasingly resemble Frida, are ever-changing and permanent. . . ."

Why then did the fame of such an incandescent artist fade within years of her death, to be rediscovered only recently by the public? The reasons that are chiefly cited have to do with chauvinism of both the masculine and European varieties. It is contended by feminists that the accomplishments of women are often obscured, and it is a fact that for many years, in spite of whatever Kahlo achieved in her own right, she labored under the burden of being "Mrs. Diego Rivera" to the world at large. In addition, she had to contend with the prevailing Eurocentrism of the modern art world, which made it difficult for any painter without classical training to gain notice.

Other reasons had to do with Kahlo herself. For many years, the habit of painting was of a private nature for Kahlo, born out of a need for self-expression. It was nearly a decade into her career before she began to perceive it as a commercial activity, and, as a result, was late in making the choices that would help enhance her commercial viability, such as painting on a large scale or using conventional materials. By the time she began to make these choices, her health was failing and she did often not have the strength to execute work of great size.

And it may also have been that Kahlo was before her time. Her imagery—often shocking—was just too radical for the public to grasp; there were even times when the pain that emanated from her work was too difficult even for her admirers. Even so, her paintings were considered precious by their owners, assiduously collected, and lovingly retained.

THE ART OF FRIDA KAHLO

However she may have once been obscured by time, the rediscovery of Frida Kahlo appears to have begun in the 1980s and stems from a number of sources, including feminism. Such a view was confirmed by Rivera's daughter, Guadalupe Rivera Marin, who, in an interview given to *Voices of Mexico* magazine, claimed that there was a modern feminist desire, for

The Frame
FRIDA KAHLO; *c. 1938; oil on metal with glass;*
11½ x 8½ in. (29.21 x 21.59 cm).
Musée National d'Art Moderne, Centre Georges Pompidou, Paris.
This painting, originally shown in André Breton's
"Mexique" exhibition in Paris, was the first painting
by a Mexican artist to be purchased by the Louvre.

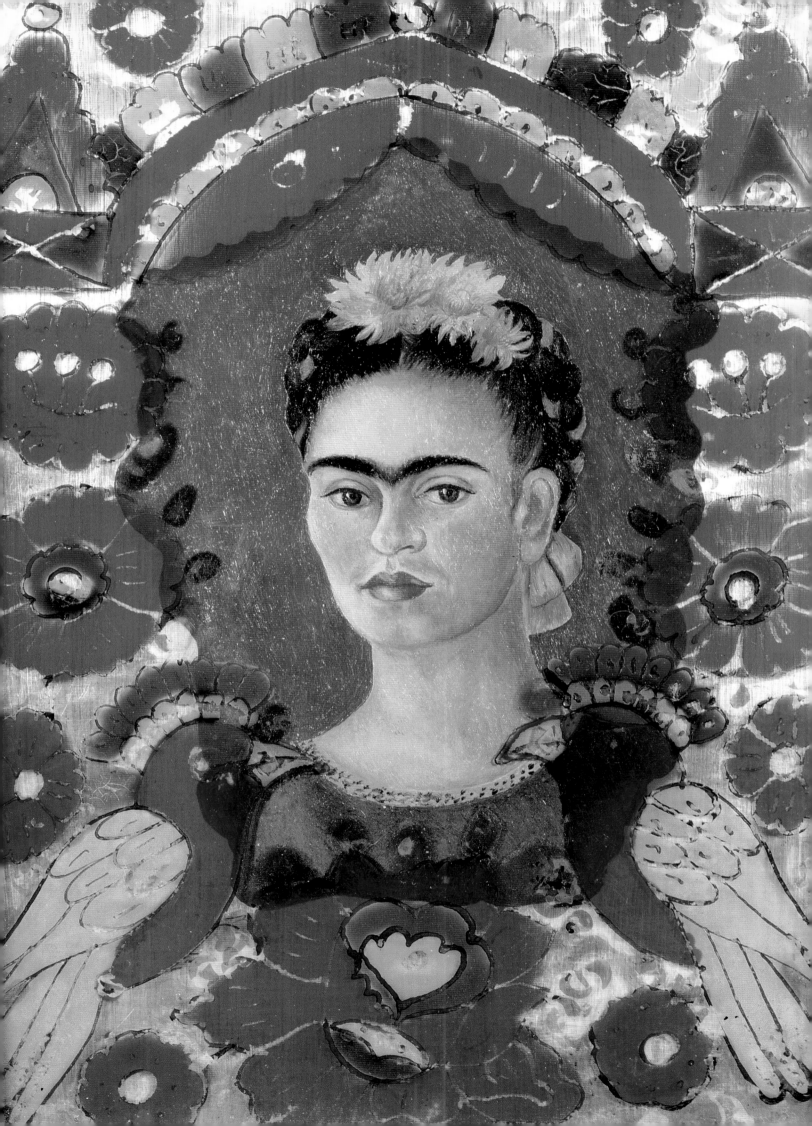

diverse reasons, to claim Kahlo as a role model. Others attribute Kahlo's growing popularity to such modern trends as "punk" expressionism, which has incorporated much of the shocking and morbid imagery—such as was often employed by Kahlo—into its nihilistic worldview.

But people are also obsessed with Kahlo the woman as well as Kahlo the artist. While alive, Kahlo had a powerful and charismatic personality that held sway over many influential persons from the world of art and politics, including her illustrious husband, Diego Rivera. She became the lover of Isamu Noguchi and Leon Trotsky, among many others. In addition, although she often denied it, she was probably among the first Surrealists of the New World.

Like the Surrealists, whose movement was born in the aftermath of the Great War, Kahlo, too, was born in a time of change. The Mexican Revolution, which would take place three years after her birth, would shake up Mexican society, as well as become a seminal experience for every Mexican artist of the time.

Mexico, however, was not alone in struggle. Dissent and unrest were everywhere. Across the world, Communism was overturning Russian imperialism,

and World War I would soon change the face of Europe. All of these influences would be integrated into Kahlo's art. But in addition to external influences, there was the intense and personal introspection that was a hallmark of her art. In part, Kahlo's dark vision was a legacy of Mexico's Mayan-Catholic culture, which includes an unusual cult of death, as well as of her own experience, which included a life of illness and several near-death episodes.

In her short lifetime, Kahlo was a prolific artist. In her some two hundred self-portraits, she most often depicted herself clothed in the costume of the peasant women of Tehuanatepec. She was often ostentatiously "Mexican," wearing necklaces of huge beads, exotic hairstyles of flowers and ribbons, as well as native costumes. Her paintings, with their often diminutive size and inexpensive materials, also reflected Mexican folk art, which found its expression through whatever means were at hand.

In reality, however, Kahlo was not the peasant with whom she identified but the offspring of a bourgeois family. She was highly educated and spoke three languages. Her style of dress had been suggested by Rivera, whom she was always willing to please, but it also satisfied her own her sense of drama and Communist conscience. Her painting style, also encouraged by Rivera, employed naive motifs while opening doors to another world.

Rivera identified Kahlo with Mexico. To understand what he meant, it is important to look at the country for which the two of them cared so much.

MEXICO

In Kahlo's early painting *My Grandparents, My Parents and I* (1936) are the elements that comprise a microcosm of twentieth-century Mexico. In this curious painting, the precocious child Frida straddles her quiet Coyoacan home, a ribbon grasped in her tiny hand connecting her to her parents and then to her grandparents. Her father's parents were from Europe, while her mother's parents, of mixed Indian and Spanish ancestry, had been settled in Mexico for centuries.

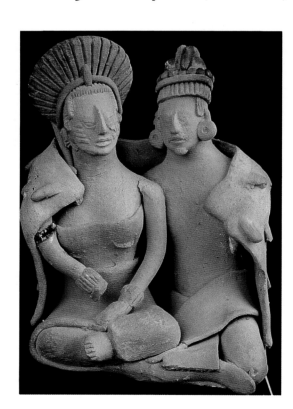

Mayan Clay Figurines

Pre-Columbian, c. A.D. 700–1000; pottery; Campeche, Mexico. Jacksonville Art Museum, Florida. Kahlo's figures often had expressions of serenity and stoicism, as seen in these antique figures; it was the other elements in the painting that told the story.

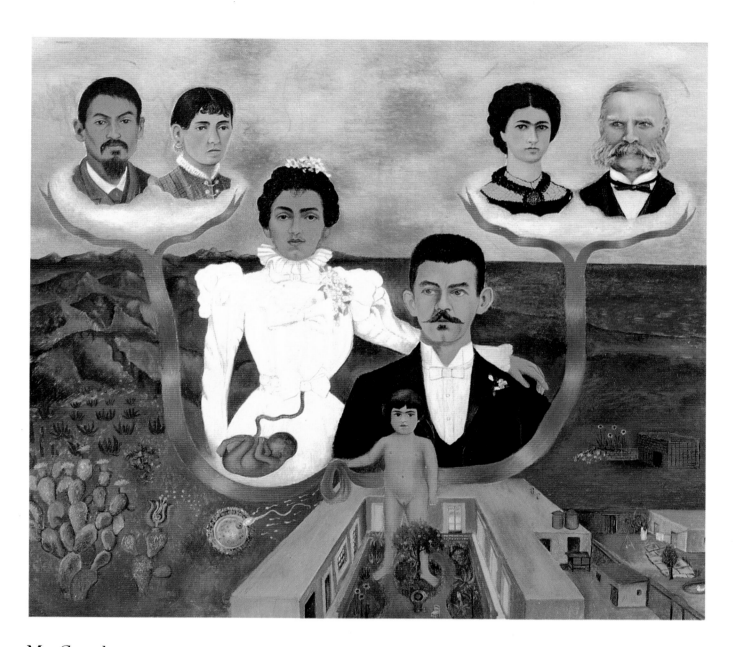

My Grandparents, My Parents and I

FRIDA KAHLO; *1936; oil and tempera on metal panel;*
12⅛ x 13⅝ in. (30.79 x 34.73 cm).
Gift of Allan Roos, M.D., and B. Mathieu Roos,
The Museum of Modern Art, New York.
In one of her earliest narrative paintings,
Kahlo traces her Mexican-European
ancestry against the backdrop of her
Coyoacan home. She appears three times in
the portrait, as child, fetus, and fertilized egg.

FOLLOWING PAGE:

Engraved Wall, Chichen Itza

Pre-Columbian, archeological site, Chichen Itza, Yucatan, Mexico.
Bas-reliefs such as these were testaments to the might of the
city-states and warrior kings. They often told the story of a
great victory, or of a mythic battle involving the god-protectors.

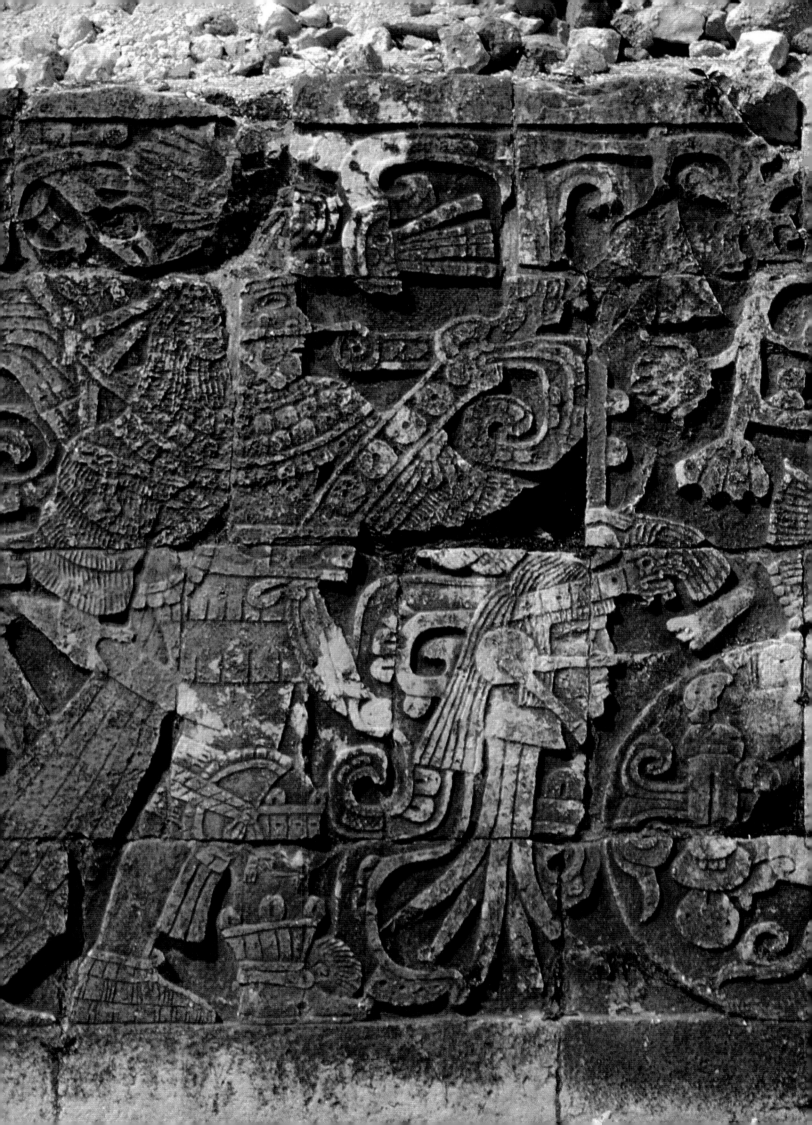

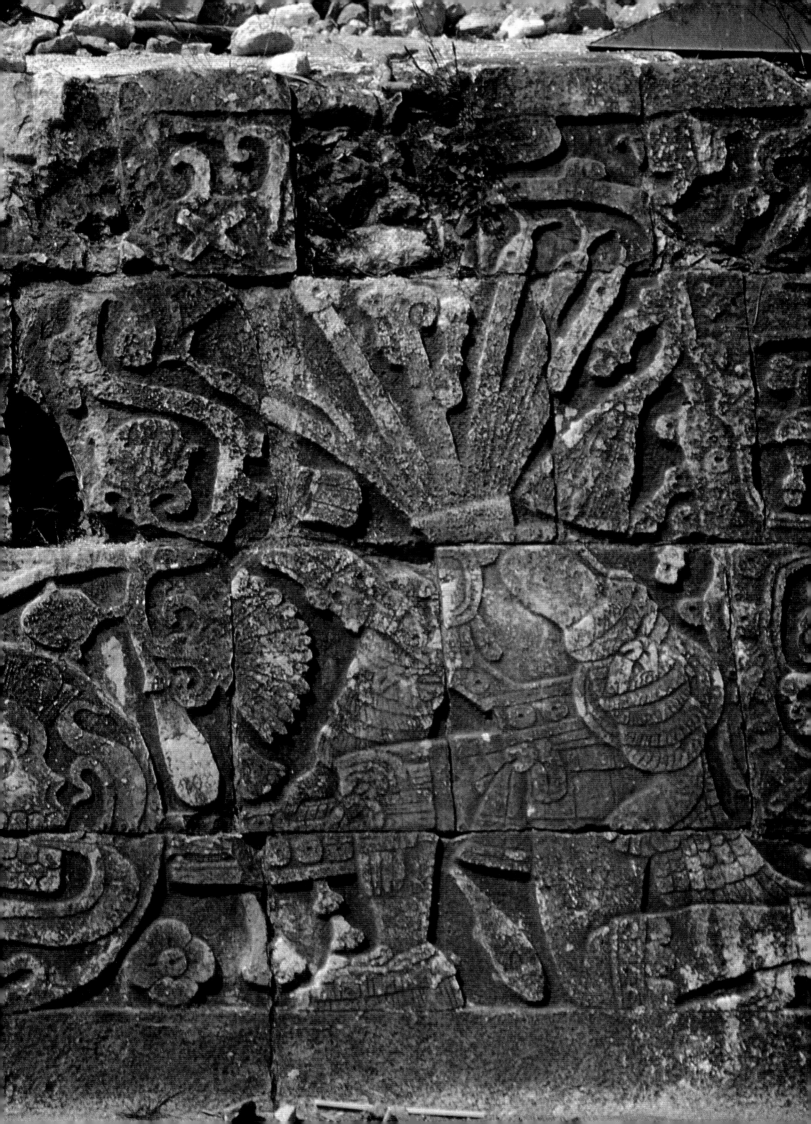

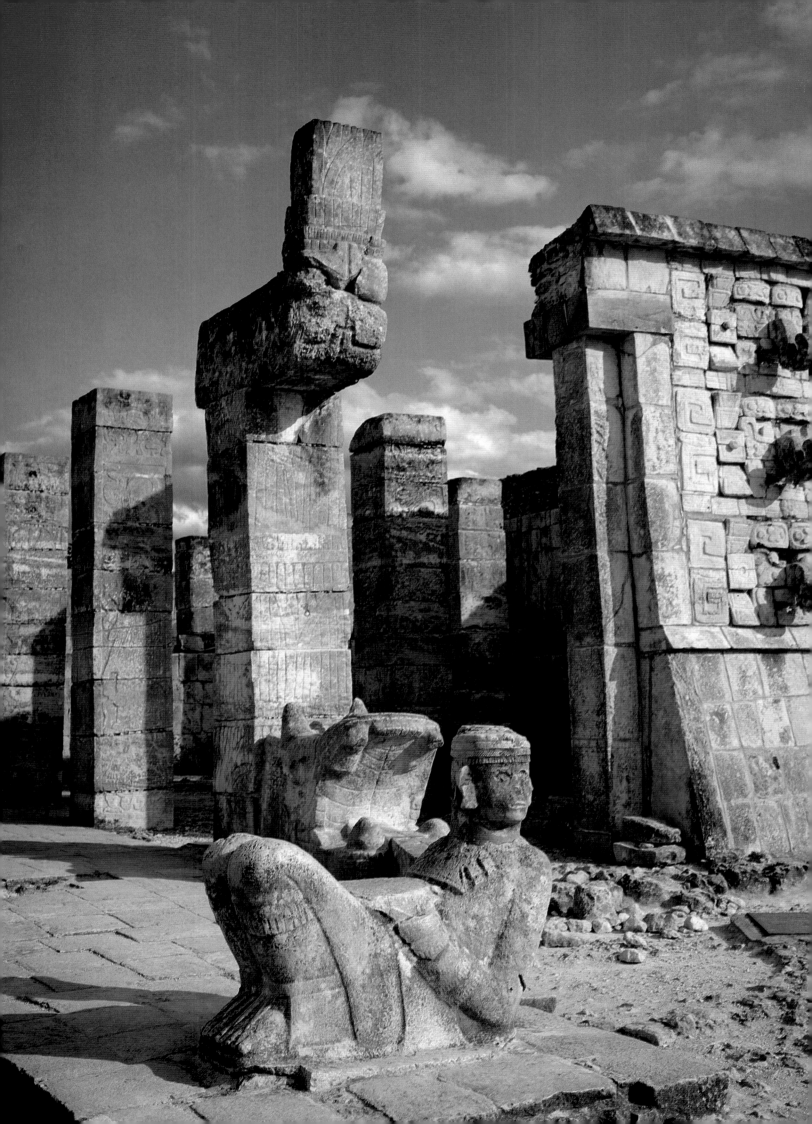

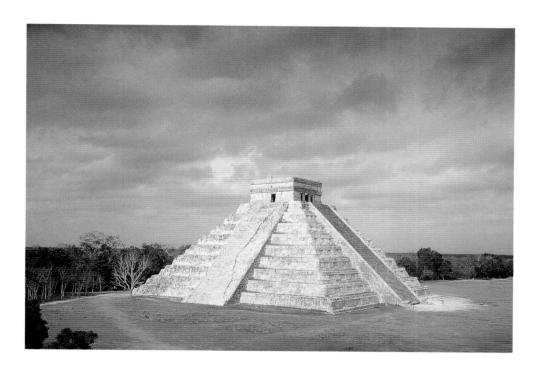

Castle Pyramid, Yucatan

Pre-Columbian, archeological site, Chichen Itza, Yucatan, Mexico. The stepped pyramids of Mexico resemble the earliest pyramids of the Egyptians. For this reason, and to explain New World civilization's absence from the Bible, the Maya were at one time thought to be descendants of the Egyptians.

Like Kahlo, Mexico had two sets of grandparents, one from the Old World and one from the New World. By the time Kahlo painted her picture, Mexico was still receiving Europeans, who were bent on conquest and speculation. In the late nineteenth century, the country had been the pawn of Napoleon III, who had installed the Austrian Maximilian II (1832–67) as emperor. In spite of Maximilian's death in 1867, Mexico City's architectural plan remains the legacy of the French. The grand boulevard of Mexico City that leads to its majestic cathedral is, for example, modeled on the Champs-Elysées in Paris.

Mexico City was also under the shadow of an earlier civilization—that of the Maya. Pyramids that have stood for centuries mark where the ancient city of Teotihuacan (c. 650 B.C.) stands to the northeast of Mexico City. An antiquity even at the time of the

Chac Mool, Chichen Itza

Pre-Columbian, archeological site, Chichen Itza, Yucatan, Mexico. This recumbent Chac Mool, or sacrificial figure, is set in front of the Temple of the Warriors at Chichen Itza. The function of the Chac Mool is unknown; it is thought to have held the heart of a sacrificial victim in its hands.

Aztecs, Teotihuacan was the first metropolis of the New World, flourishing from A.D. 100–600. Its Pyramid of the Sun Citadel and the Temple of Quetzacoatl, within sight of the modern city, remain solemn reminders of a murky past, one that had—until recently—been willfully obscured by the conquering Europeans.

The Teotihuacan site has been a treasure trove, and the many artifacts found there include a funerary mask, composed of a jade mosaic set into stone, a gold mask complete with mold, and murals depicting the amazing gods and legendary animals of the ancient people. Teotihuacan was a city of the Olmecs, an indigenous people of Central America who were old even by Aztec standards. They were an agrarian people who had built the continent's first civilization.

The Mayan people had city-states throughout Mexico and Central America. They were expert timekeepers, able to follow the motions of the stars, by which they were able to predict both the weather and the future. Each city-state had a king, who, in the beginning, was a great leader chosen for his merit from aristocratic families. Later, as the meritocracy eroded, it was replaced by a hereditary monarchy.

In Mayan culture, the king was directly responsible for establishing a channel of communication between the real world and the occult world, where the gods

dwelt. These were terrible gods who demanded blood sacrifice. Mystic ceremonies involving the shedding of blood through self-mutilation were performed by the king to keep both the gods and the people healthy. Other human sacrifices were made throughout the Mayan civilization.

The descendants of Mayan culture—Olmec, Toltec, and Aztec—flourished in Mexico for centuries, while war among the city-states assured a steady flow of sacrifices to propitiate the gods. By the time the conquistadors landed in the sixteenth century, however, events had been going poorly. There was famine, due to fertile soil have been depleted by the cities and their monuments. War was bitter, but inconclusive. When the Spanish conquistadors were mistaken by the Aztecs for the second coming of their god Quetzacoatl ("the Plumed Serpent"), the Spanish were able, through this superstition and by pitting one city-state against another, to conquer and enslave the Aztecs.

Moreover, the Spaniards brought the diseases of the Old World with them, to which the Aztecs had no immunity. This combination of events served to literally destroy the record of the Mayan civilization. In the centuries following the Spanish conquest, Mayan culture was almost completely expunged from memory. Only by the nineteenth century did it begin to resurface. Indeed, when John L. Stephens and Frederick Catherwood discovered the ruins of Palenque in 1854,

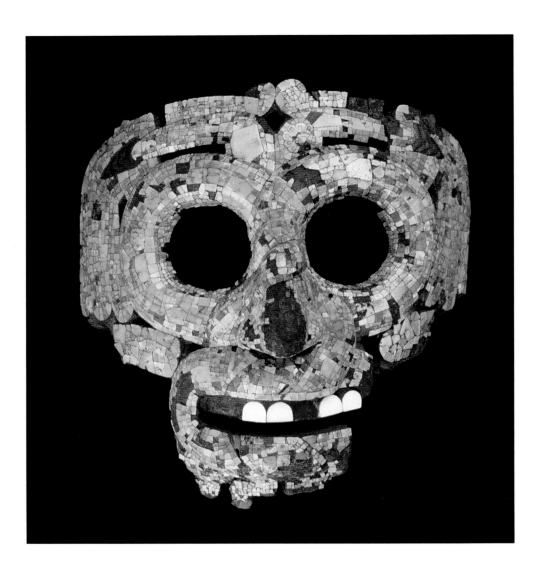

Mosaic Mask of Quetzalcoatl

British Museum.
The Aztecs mistook Cortez for Quetzalcoatl, the "winged serpent god," whose second coming had been foretold.

The Goddess Tlazolteotl in the Act of Childbirth

Pre-Columbian.
Aplite with garnet
inclusions. Dumbarton
Oaks, Washington, D.C.
This antique sculpture, which is remarkably expressive, depicts the Aztec goddess of filth giving birth to a mature human figure. When Kahlo painted *My Birth*, she covered the face of her mother.

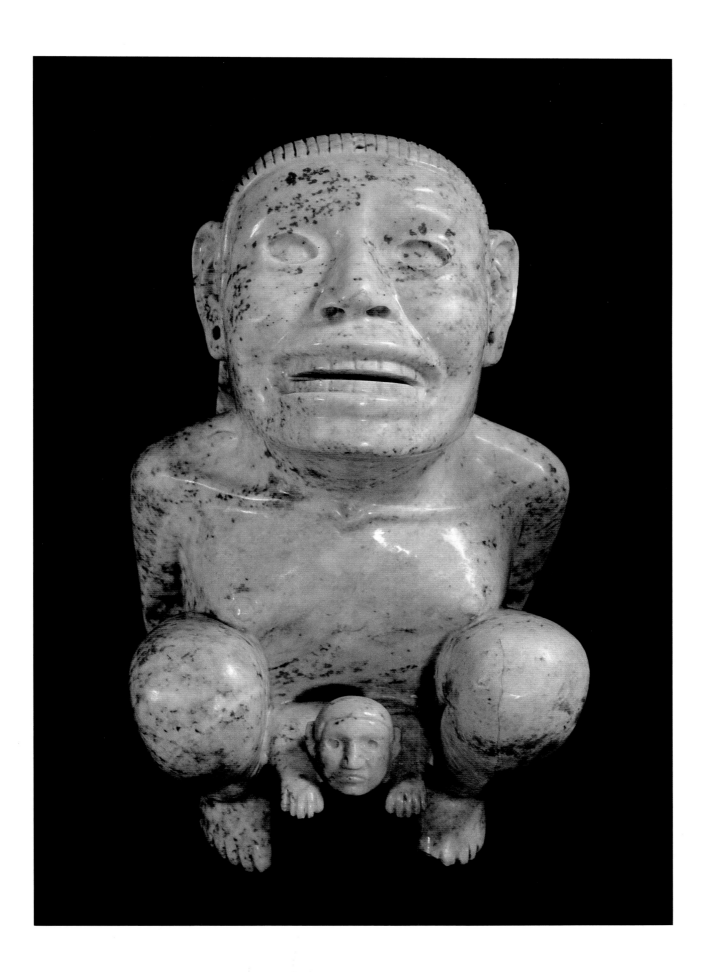

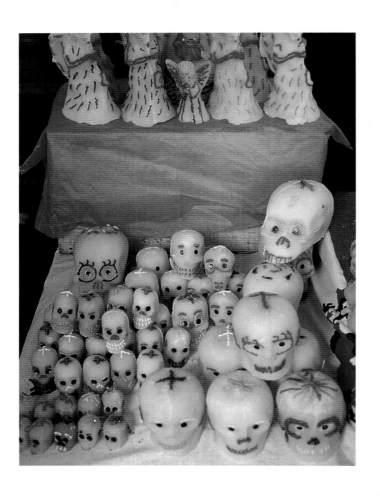

no one could quite remember the civilizations that had existed centuries before the conquistadors. In fact, because people were reluctant to believe that a civilization not mentioned in the Bible could be possible, the ruins were first ascribed to the Egyptians.

The conquistadors supplanted the civilization they found with that of their own, and enslaved the native population to fellow Spaniards who were coming to the New World. They enforced their way of life on the Indians, burning most of the books kept by the Maya (except for a few codices preserved, ironically, by priests) and building their churches on the sites of ancient worship. All former knowledge was lost, and the Maya became unlettered in their own culture.

The Spaniards also supplanted the religion of the Maya with Christianity, converting the natives by force. The missionaries did their work well, blending their late medieval Catholicism—a type that abounded in revelations of *mementi mori* and the afterlife—and with this religion they captured the imagination of the natives, due in part to the sheer misery brought by the Spaniards to the rest of the population. The combination has produced Mexico's unusual culture, as evidenced in architecture and folk art, for the native Mexicans identified strongly with the saints, and with the medieval cult of death.

Sugar Skeletons and Skulls

A traditional Day of the Dead offering is a skull made of sugar with an individual's name on it. Rivera once gave a sugar skull to Trotsky on which the revolutionary's name was inscribed. Trotsky, who was the victim of several assassination attempts, was not amused.

Altar with Offerings for the Dead

On the Day of the Dead, the people remember the dead with food, offerings, and other festivities. Families visit the cemeteries and hold picnics on the graves of their ancestors. Traditions such as these might be centuries old.

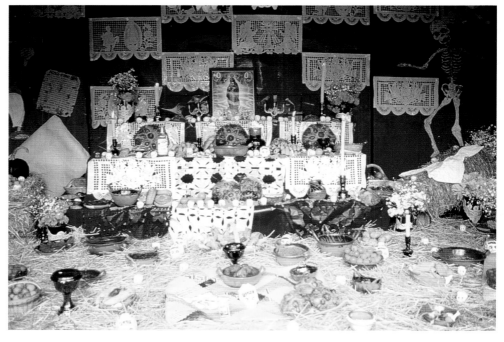

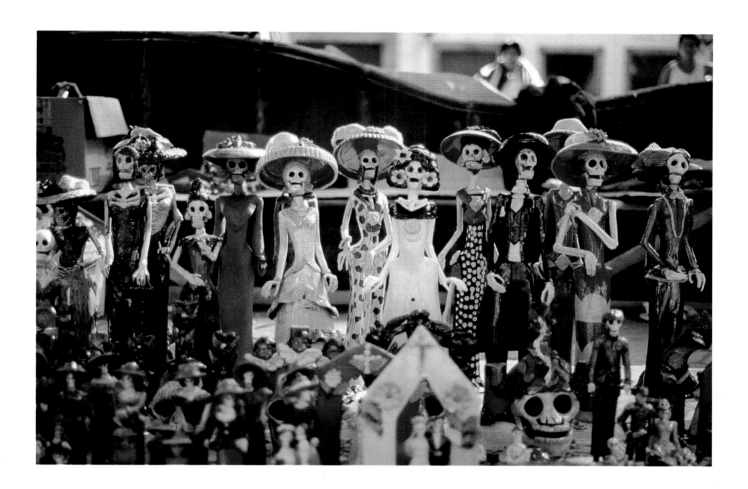

Today, this attitude is reflected in the Latin American religious holiday, the Day of the Dead. On this day, the dead are remembered through feasting held in cemeteries and through celebrations, in which skeletons and other images, called Judases, abound. These modern *mementi mori* are found everywhere, and include everything from papier-mâché puppets to sugar cubes in the shape of skulls.

One manifestation of this religious cohesion of Old and New World beliefs is the Mexican legend of the Virgin of Guadalupe. Early in the sixteenth century, the Virgin Mary appeared to a poor peasant. The Virgin's image then appeared on the peasant's cloak, which became a relic that in time was used to heal the sick and convert pagans, and a shrine was built to house it. In the eighteenth century, with countless miracles attributed to her influence, the Virgin of Guadalupe became the first patron saint of New Spain.

The Virgin of Guadalupe is a beautiful icon, a

Skeleton Figures in the Marketplace, Patzcuaro, Mexico.

Mexico's Day of the Dead is a unique festival that celebrates the place of death in life. Mexican culture combined the ancient beliefs of the Maya with a touch of medieval Spanish *mementi mori*. The result is remarkable.

striking image that has commanded worship since its acceptance. In the icon, the Virgin appears in a royal blue robe, in the center of a flaming mandala. The icon is often surrounded by gilded stars. It is to be found everywhere in modern Mexico.

As an image of protection, the Virgin of Guadalupe often appears in *retablo* art, folk paintings that tell the story of a healing, and are given in thanks for a successful recovery. *Retablo* paintings would later provide a crucial direction for Frida Kahlo, whose own life was filled with the ebb and flow of sickness and healing.

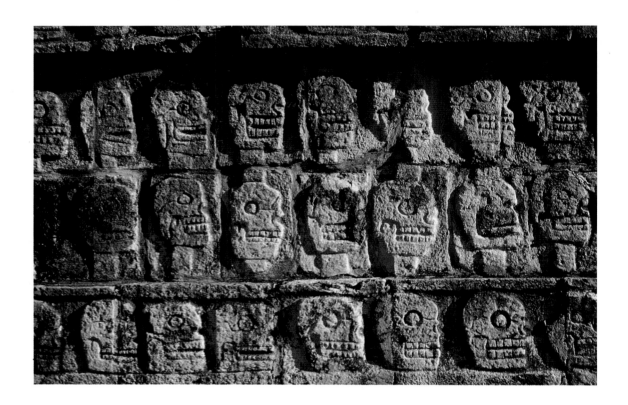

Wall of Skulls

Archeological site, Chichen Itza, Yucatan, Mexico.
The wall of skulls at Chichen Itza is an
arresting sight, and demonstrates how far
back the Mexican preoccupation with *mementi
mori* goes. Its contemporary equivalent can
be seen every Day of the Dead, when sugar
skulls line the merchant stalls in the marketplace.

Self-Portrait "Very Ugly"

FRIDA KAHLO; *1933; fresco panel; 27²/₅ x 22¹/₅ in.
(69.6 x 56.4 cm). Private collection.*
This was Kahlo's first and only attempt at
using the medium of fresco for her art.
She was obviously influenced by Rivera's
own frescoes in her choice of material.

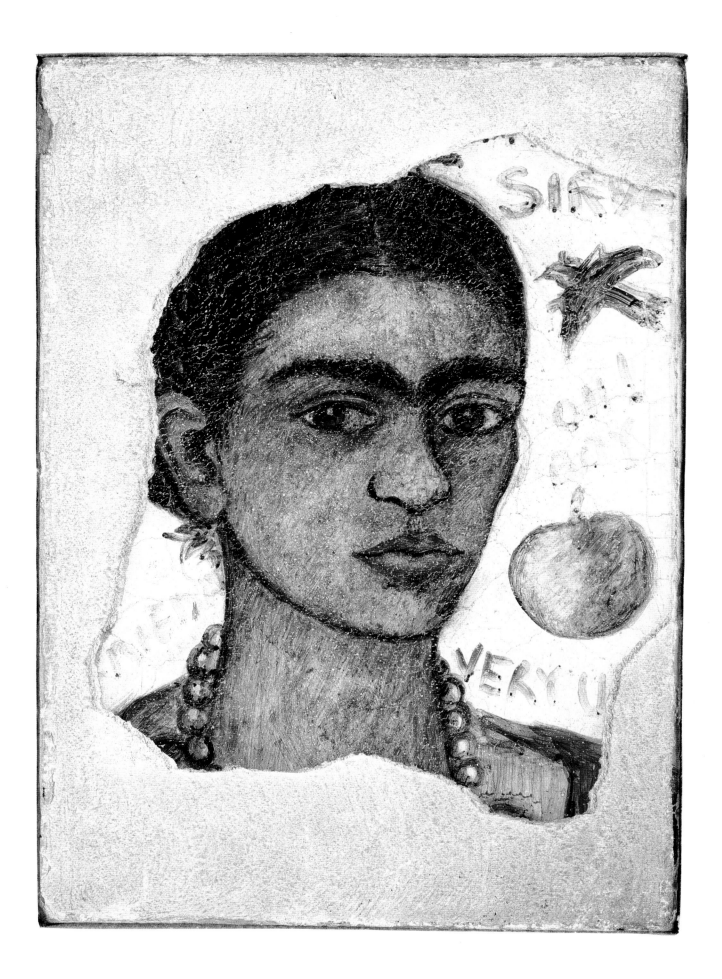

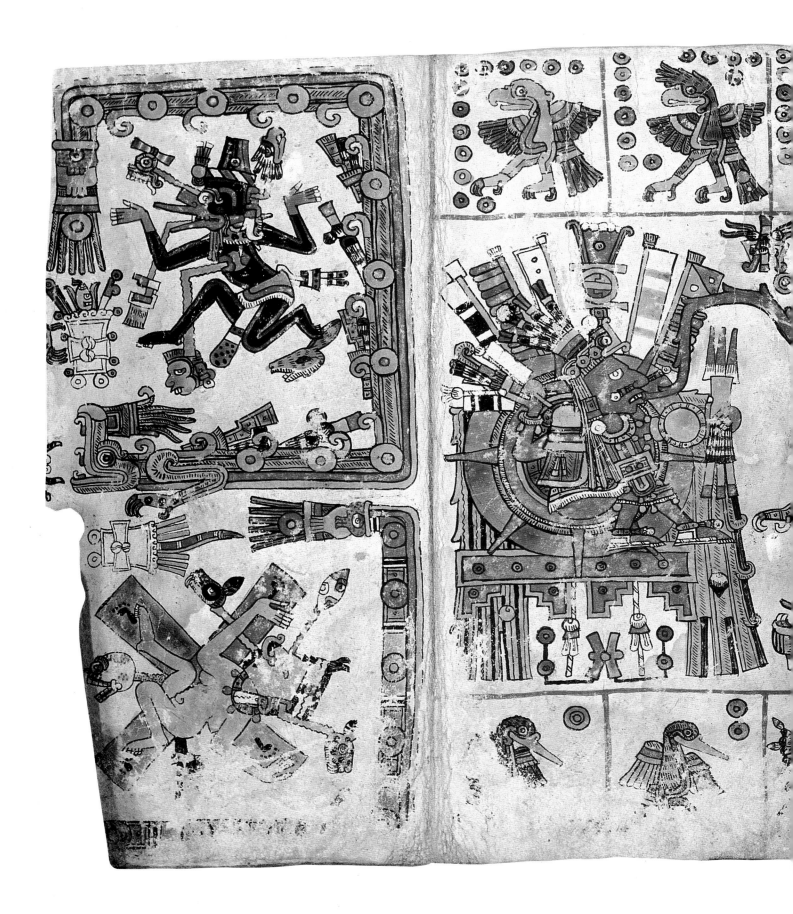

Page from the Codex Borgia

c. 1600; illuminated manuscript.
Vatican Library.

Here is a page from one of
only two codices, preserved
by Spanish missionaries,
that remain from the
literature produced by the
vastly literate ancient Maya.

Pueblo Couple

n.d.; folk art; ceramic tile.

Here is a charming, if stereotypical, depiction of life in
"Old Mexico." In contrast to this type of nostalgia, the
Riveras turned their attention to the country's Native American
culture; Frida in Tehuana costumes, Diego in his heroic murals.

Michoacan Painted Chest

n.d.; folk art. National Museum of Folk Art, Mexico City.
Items such as this chest represent the wealth of decorative
detail that is typical of Mexican folk art. Vivid colors against a dark
background, and dangerous animals set amid birds and flowers,
show the juxtaposition between the dangerous and the mundane.

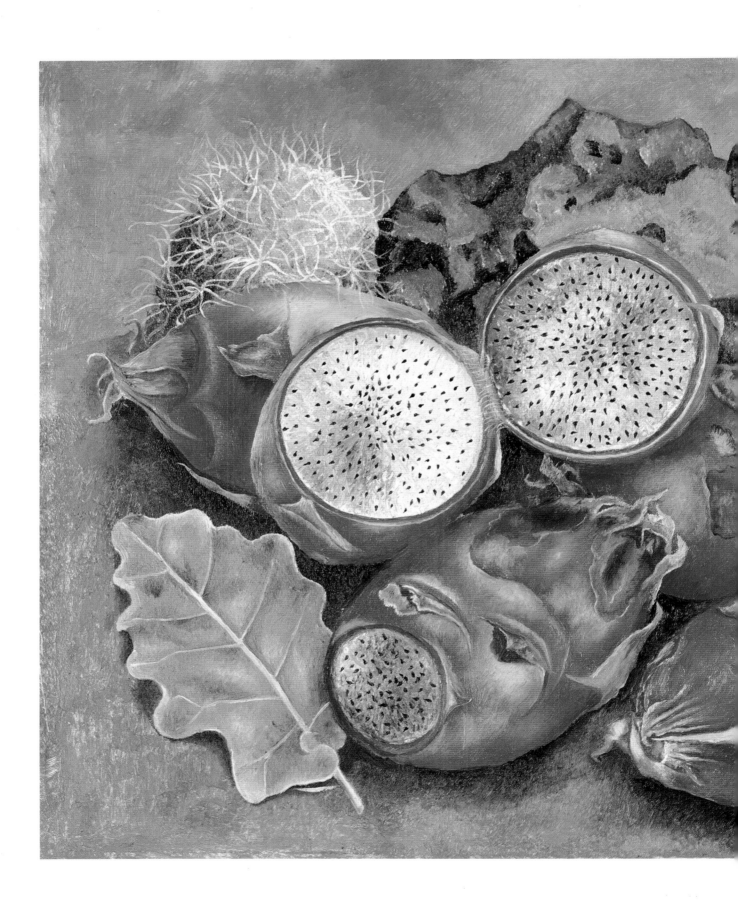

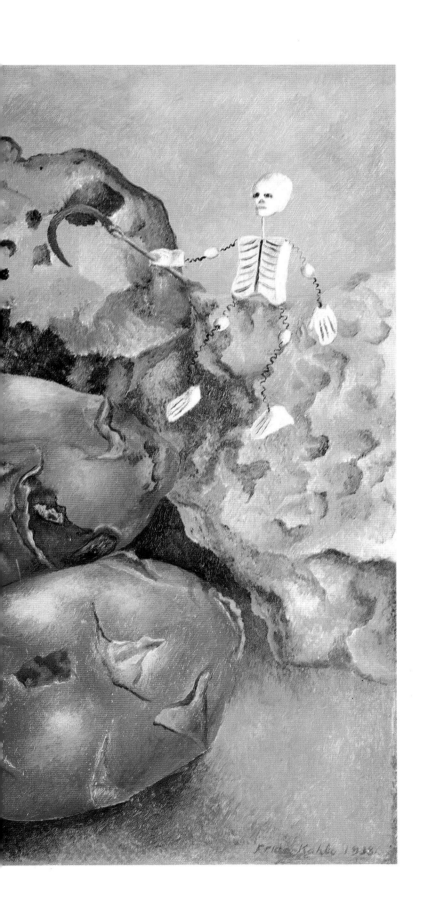

Pitahayas

Frida Kahlo; *1938; oil on metal; 10 x 14 in.*
(25.4 x 35.56 cm). Bequest of Rudolph and Louise Langer,
Madison Art Center, Madison, Wisconsin.
Kahlo's still lifes nearly always contained not
only disturbing elements of eroticism, but in
their bursting, overripe, corrupted state, the
fruits contained references to her own wounded
body. To this painting is added a tiny skeleton,
which emphasizes the air of decay already present.

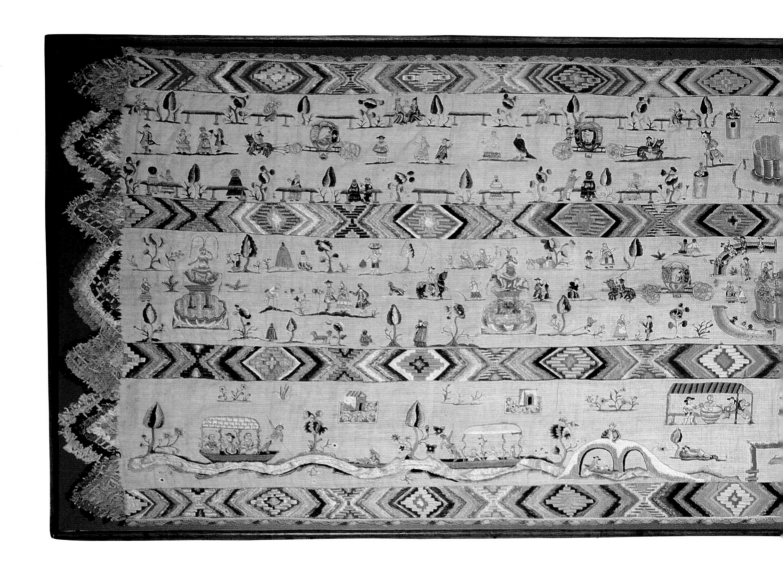

Rebozo

c. 1790; folk art; silk: with silk, gold, and silver thread; 28½ x 87 in.
(72.4 x 221 cm). Parham Park, West Sussex, Great Britain.
Rebozos (long shawls) are worn by Mexican women
of all classes. While they are generally woven of
cotton or wool in a geometric design, this elaborate
silk rebozo depicts the environs of Mexico City:
the Zocalo, Alameda Park, and Islands of Xochimilco.

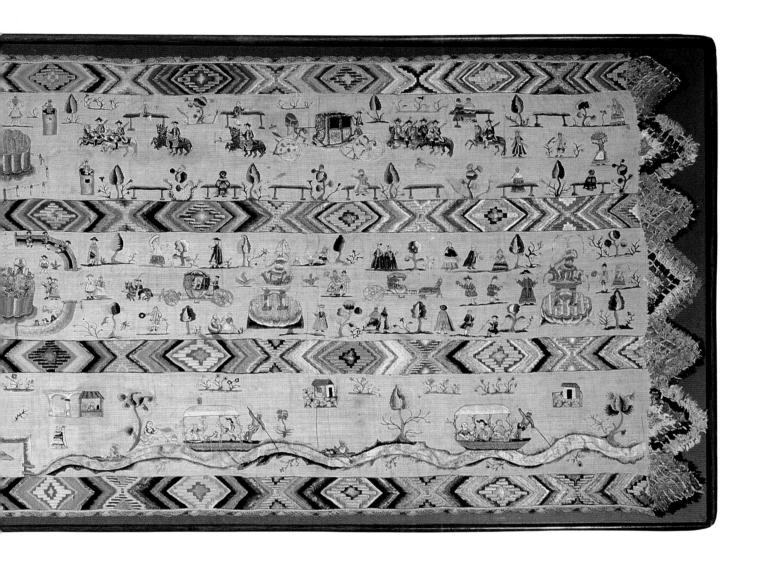

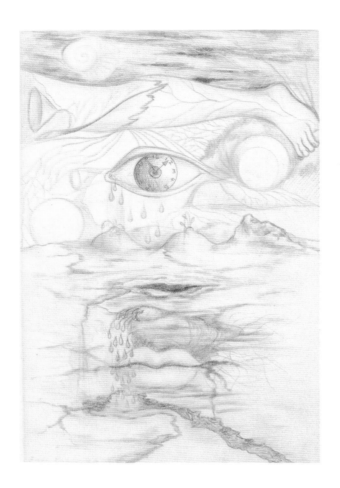

Fantasia

Frida Kahlo; *1944;*
drawing; Fundacion
Dolores Olmedo, Mexico City.
Kahlo's sketches were
often done automatically,
one thought following
another. In this respect,
she was like the Surrealists.

"Tree of Life" Candelabrum

Izucar de Matamoros; *1989; ceramic;*
Puebla, in the style of Aurelio Flores. British Museum.
In the Mexican culture, death is not a taboo subject
to be shunned but an integral part of living. This
attitude appears to arise from a synthesis of the origi-
nal native culture and a medieval Spanish sensibility.

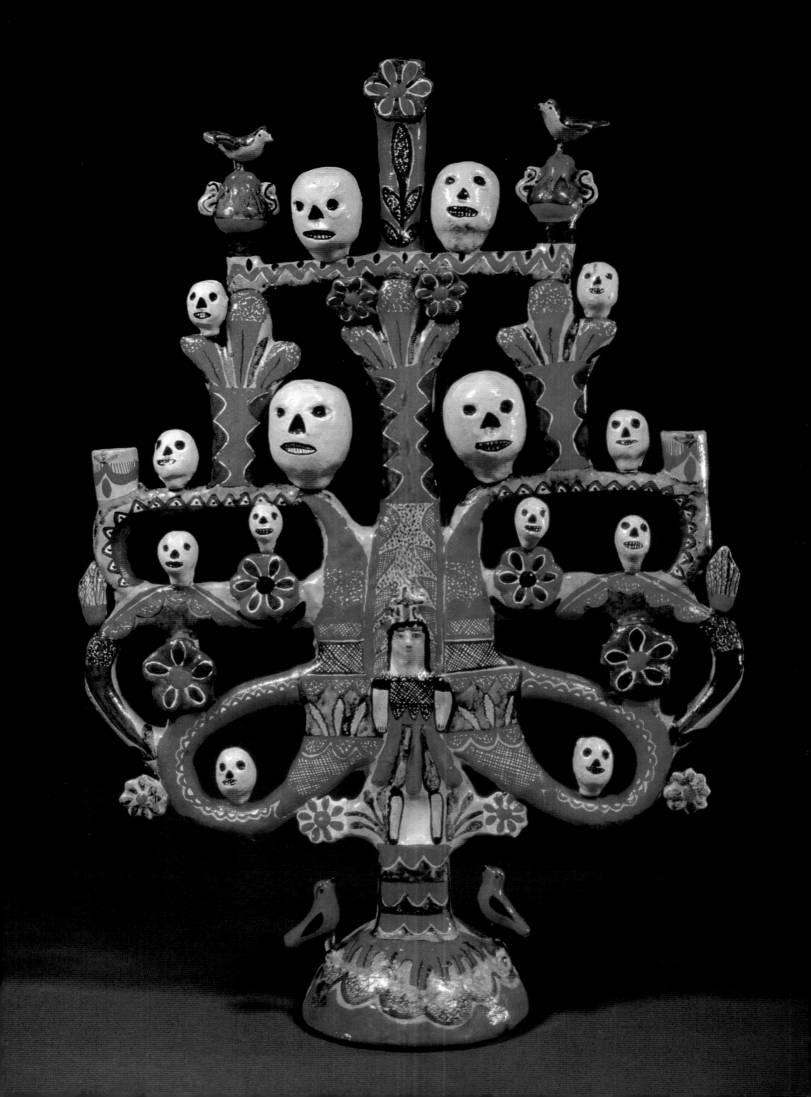

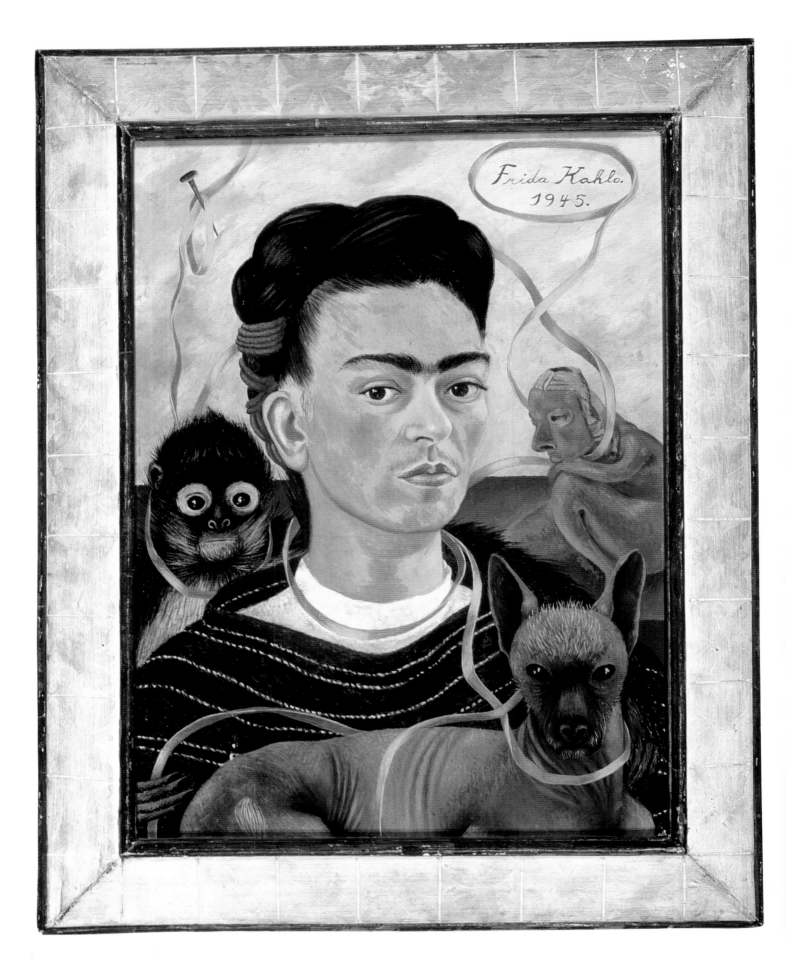

FRIDA AND MEXICO 1907–1922

Frida Kahlo was born Magdalena Carmen Frieda Kahlo on July 6, 1907. Her parents were Guillermo Kahlo and Matilde Calderon. Kahlo's father was a Hungarian-German Jewish immigrant; a foreigner with no particular prospects whose original name had been Wilhelm Kahl. He had come to the New World after epileptic seizures cut short an academic career in his native Germany.

Kahlo's mother was a native Mexican of Spanish and Indian descent. Before meeting Guillermo (they worked at the same store), she had been engaged to another German, who had committed suicide. She appeared to be a woman of superior, if sometimes unyielding, moral strength, and was the backbone of her family.

Kahlo was the third of four daughters of Guillermo and Matilde (Guillermo had two daughters—Maria Luisa and Margarita—by a previous marriage), the others being Matilde, Adriana, and the youngest sister, Cristina.

Like many a son-in-law before him, Guillermo Kahlo had gone into his father-in-law's business—which was, in this case, photography. It was propitious for him, since he turned out to have a great deal of talent for it. Guillermo received a commission from the Mexican government to become the first official pho-tographer of Mexico. His career, however, was cut short by the outbreak of the Mexican Revolution (1910–20).

THE REVOLUTION

At the time of Kahlo's birth, Mexico had been an independent nation for fewer than one hundred years. Furthermore, the United States had taken advantage of the young nation's century-long birthstruggle, seizing California and Texas.

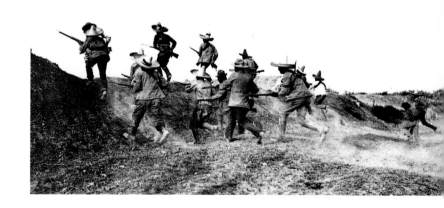

Self-Portrait with Changuito

FRIDA KAHLO; *1945; oil on canvas; 23½ x 16¾ in.*
(59.69 x 42.54 cm). Fundacion Dolores Olmedo, Mexico City.
Kahlo continued to paint her remarkable self-portraits
throughout her life. Here, she connects herself
with ribbons to various Mexican symbols—an *ixcuintle* dog,
a spider monkey, and a pre-Columbian figure.

Villa's Troops Rushing Federal Lines Under Protection of Cannon

1913; archival photograph. Bettmann Archives.
Times were bitter in the tumult following the assassination
of President Madero. Pancho Villa, a former *bandido*, resisted
the *Federales* in the north of Mexico. So popular was he that
the United States regarded him as a danger to the border.

The Mexican Revolt, November 1913

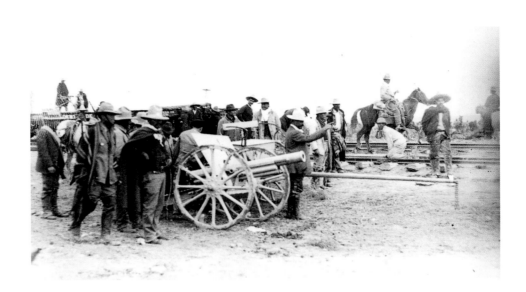

1913; archival photograph. Bettmann Archives.

The Mexican Revolution, which began in 1910, raged for many years as a succession of generals competed for leadership. For Kahlo, the struggle was a source of pride; she said that she was born three years later than she actually was in order to be able to claim that she was born "in the Revolution."

Kahlo would later change her birth date to 1910 and claim she had been born during the Revolution. But by the time that the Mexican Revolution commenced, Mexico had actually been engaged in a struggle for independence from the Spanish incursion for about a century. It had begun in 1810. The priest Miguel Hidalgo y Costilla, with his speech "*Grito de Dolores*" ("Cry of Sorrows") and a banner emblazoned with the Virgin of Guadalupe, roused the Indians to revolt; this struggle eventually led Mexico to declare independence from Spain in 1821. Subsequent struggles resulted in a modern, if despotic, government under General Profirio Diaz, who at the time of the 1910 Mexican Revolution had been serving as president since 1884.

Diaz had promised free elections in 1910, which inspired Francisco I. Madero to put himself forward as a candidate. When Diaz rigged the election in his favor, Madero, assisted by Pancho Villa (1878–1923) in the north and Emiliano Zapata (1879–1919) in the south, led a revolt against him and became president. Madero himself was overthrown and executed in 1913, flinging the country back into the maelstrom of anarchy that lasted until 1917. It was a violent time, captured in the broadsides and sketches of the well-known artist Jose Guadalupe Posada (1851–1913), whose acerbic works included his *calavera* engravings, in which skeletons became thinly veiled symbols of the power-hungry. The Kahlos experienced the chaos firsthand. Frida recalled the fighting in the streets near their home: "In

1914, the bullets just hissed. I still hear their extraordinary sound."

Kahlo's childhood was also marred by personal tumults. In 1913, at the age of six, she contracted polio, which affected her right leg. Recovery from the disease took nine months, after which the muscles of her right leg became weak and atrophied. The unwelcome taunts caused by the affliction distressed Kahlo and made her extremely self-conscious.

It was at this time that Kahlo grew close to her father, with whom she now shared the burden of illness. The retiring Guillermo was remote to the rest of his family, preferring to spend his free time at the piano and with the works of the German philosophers. However, he found time for Frida, taking her to parks and helping her build up the strength in her fragile leg. In addition to athletic activities, Guillermo also took her on nature walks. Frida would gather specimens that Guillermo would allow her to view with his microscope. Theirs was a close relationship based on intellectual and creative pursuits. It was much different from the one Kahlo experienced with her disciplinarian mother, whom she called El Jefe ("the boss").

When Frida was ten, Mexico implemented a new constitution that included a number of reforms, including land, workers rights, and the separation of church and state. In 1920, General Alvaro Obregon overthrew the president, Venustiano Carranza, and established what became the "Northern Dynasty," which essentially ruled Mexico from 1921 to 1933

through a succession of presidents. While it brought needed reforms to the countryside and to urban workers, it also ruled through terrorism. The people of Mexico had gained some freedom, but the dark side of power was still present.

SCHOOL DAYS

Kahlo experienced one of the many Northern Dynasty improvements firsthand in the form of the National University, which had been revived in 1910. In 1922, Kahlo, with the encouragement of her father, entered the National Preparatory School, which was part of the University. She was one of thirty-five girls to do so, out of a student population of two thousand. Needless to say, these girls were the object of a great deal of attention; Kahlo, by this time an outrageous extrovert, enjoyed it.

At the National Preparatory, she became part of a group called Las Cachuchas, composed of nine members, some of whom were immortalized by Kahlo in portraits, and with whom she remained friends for life. Las Cachuchas were considered to be a group of precocious intellectuals. Although they spent many hours reading literature and philosophy at the library, they also spent much time playing pranks on their teachers, one of which was supposed to have caused Kahlo's expulsion, if only temporarily.

Among the Cachuchas was Alejandro Gomez Arias, who was to become one of Mexico's leading intellectuals. Arias was Kahlo's first boyfriend, to whom she wrote many passionate letters, dotted with small drawings. In 1922, she sent him one of her earliest pictures of herself.

Zapata and the Federales

Jose Guadalupe Posada; *1910–1912; cartoon.*
Emilio Zapata was a rebel leader from the south of Mexico who, like Pancho Villa in the north, harried the *Federales* with an army made up of peasants. Zapata was murdered in 1919.

Calavera Huertista

JOSE GUADALUPE POSADA;
1911; engraving.
Museo Nacional de Arte
Moderno, Mexico City.
The artist Jose
Guadalupe Posada was
popular because of his
lurid wit and political
satire. Here, in one of
his celebrated *"calavera,"*
or "skeleton," prints,
he depicts the dictator
as a malevolent monster
composed of a spider,
a rat, and a corpse.

It was also at the National Preparatory that Kahlo, at fourteen, first encountered the painter Diego Rivera. Rivera was engaged in painting *The Creation*, one of his earliest commissions, a mural for the National Preparatory School.

The painter was then thirty-six; he had studied painting in Europe, having found inspiration in such artists as Francisco Goya, as well as in moderns such as Cézanne and Picasso. He was a Communist and wore a gun on his hip to protect himself from his many enemies. Though palpably unattractive, he was also strangely irresistible to women, and was seemingly able to choose at any time from a veritable bevy of lovers.

It seems that the young Kahlo was obsessed with Rivera and would watch him for hours. At other times, she would play tricks on him, calling him Panzons or "Fat Belly." When Rivera met her again much later, he was surprised to find that Kahlo was the little girl who had made so much trouble for him.

At the National Preparatory, Kahlo confessed to one of her Cachucha girlfriends that she wanted to have Rivera's baby. But in all that the future held for Kahlo, in all of the life that she would share with Rivera, motherhood was one thing that would never come to pass. Diegelito, as she would later call him, would be her only child.

Diego and I

FRIDA KAHLO; *1949; oil on masonite; 11⅝ x 8¹³⁄₁₆ in.*
(29.65 x 21.13 cm). Mary-Anne Martin Fine Arts, New York.
Here, in one of Kahlo's many paintings of herself and
Rivera, the artist employs some of her later symbolism. Rivera
appears as a "thought" in the middle of Kahlo's forehead;
Rivera himself has a third eye, indicating Kahlo's esteem for him.

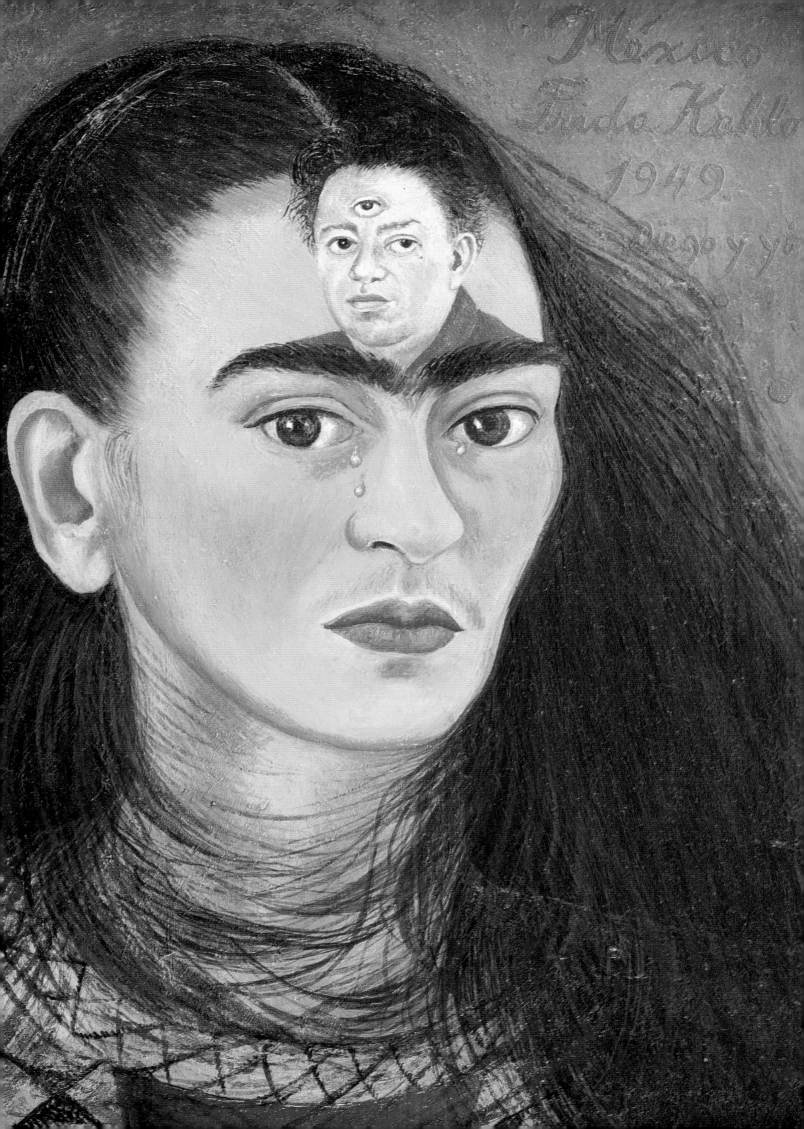

México
Frida Kahlo
1949
Diego y yo

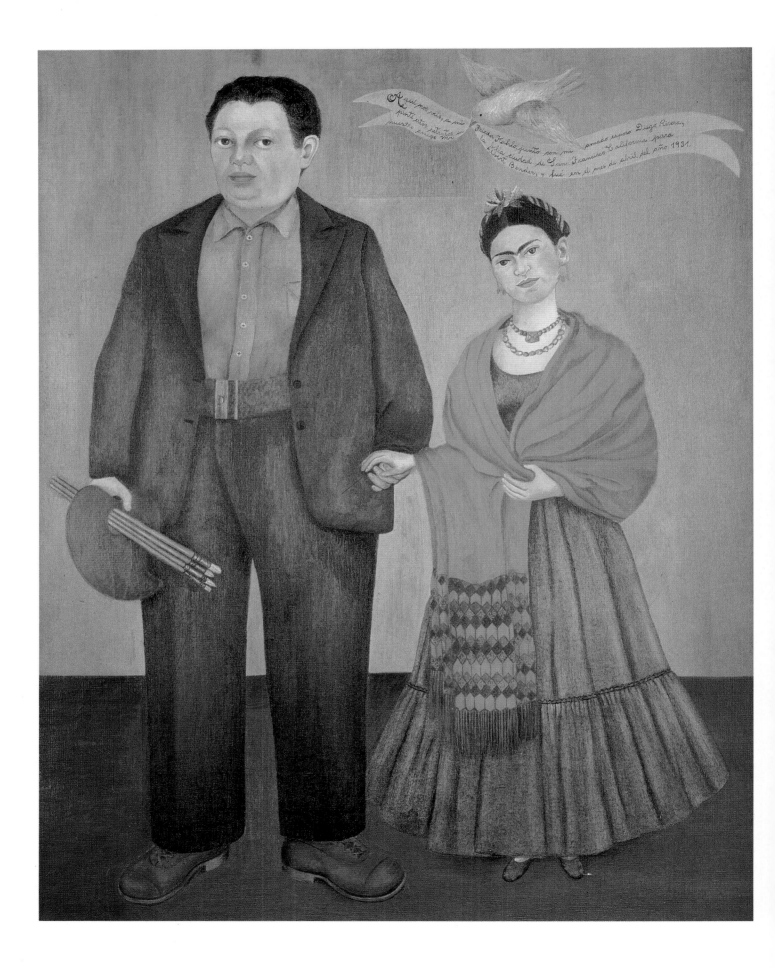

THE TWO ACCIDENTS 1924–1934

In later years, Kahlo was to say that she met with two accidents from which she never recovered: "One in which a streetcar knocked me down. . . . The other accident is Diego." While both of these events were in a sense catastrophic to the young woman, they were also instrumental in awakening the artist within her and molding the extraordinary individual she was to become.

On September 17, 1925, Kahlo switched from the trolley car she was used to taking into Mexico City to a new, wooden bus. The bus was attractively colorful and convenient. Riding along with Kahlo was her boyfriend, Alejandro Gomez Arias.

Temporarily forgotten were the financial troubles afflicting the Kahlo family, which were threatening Kahlo's continuing attendance at the National Preparatory School and her ambition to become a doctor. The lovers were enjoying the ride and each other's company.

What happened next is the stuff of legend peculiar to Mexico. The paths of the bus and the streetcar converged; since neither driver would give way, the streetcar at first stuck the bus, then began ever so slowly to grind it into a wall.

Frida and Diego Rivera

FRIDA KAHLO; *1931; oil on canvas; 39¹/₈ x 31 in. (99.37 x 78.74 cm). Albert M. Bender Collection, Gift of Albert M. Bender, San Francisco Museum of Modern Art.*

This is the wedding portrait Kahlo painted for Rivera almost two years after the actual wedding. Rivera holds his paints in one hand and Kahlo in the other. Perhaps this portrait is a wish that Rivera would always be thus occupied.

"LA BAILARINA"

In the melee, Kahlo had returned to her seat to retrieve her new parasol, a frivolous act that would have tragic consequences and upon which she would later reflect:

I was an intelligent young girl, but impractical in spite of all the freedom I had won. . . . The first thing I thought of was a *balero* with pretty colors that I had bought that day. . . . I tried to look for it, thinking that what had happened would not have major consequences.

In Arias' account of the accident, the wooden bus bent under the pressure of the streetcar, then suddenly burst in an explosion of splintering wood. Arias was thrown to relative safety beneath the streetcar. When he scrambled up to look for Kahlo, his eyes met an incredible sight.

First, the explosion had blown off all of Kahlo's clothes. She was naked and transfixed by the iron guardrail of the bus, which had her pierced her through. (Kahlo later claimed, somewhat conveniently, that the pole had "deflowered" her by coming out through her vagina.) Even more bizarre, a bag of gold dust carried by a passenger (presumably a painter) had also burst in the crash, turning Kahlo's naked, bleeding, and mutilated body into a golden statue.

The crowd that had gathered because of the accident pointed to Kahlo and shouted "*La Bailarina! La Bailarina!*" (meaning "the dancer"), as if they were encountering a miracle.

But one man, horrified at the sight of the rail projecting from Kahlo, cried to Arias, "We must get that

out of her!" He began pulling the rail, which caused Kahlo to scream louder than the siren of an ambulance that was arriving on the scene. Then, according to Kahlo, the man carried her from the accident site to a bar, where he laid her on a pool table.

Kahlo was taken to the Red Cross hospital, where she was placed with the accident victims who were expected to die. Much later, she was operated upon, but no one thought she would live. Her spine had been broken in three places; her right foot had been crushed, and her right leg and collarbone were fractured.

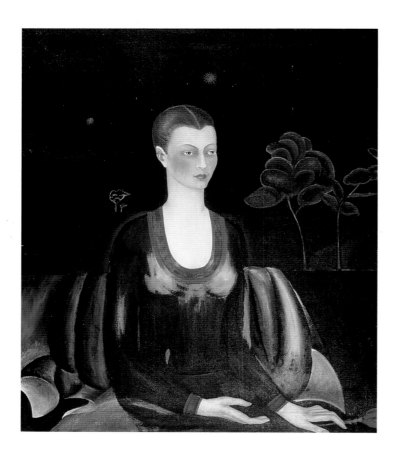

Portrait of Alicia Galant

FRIDA KAHLO; 1927; oil on canvas; 42 x 36¾ in. (106.93 x 93.47 cm). Fundacion Dolores Olmedo, Mexico City. This portrait, with its velvet colors, show Kahlo's ability to capture resemblance. It is characteristic of her early work, before Rivera encouraged her to look for inspiration from the Mexican world.

RECOVERY AND REHABILITATION

Kahlo would spend three months at the Red Cross hospital. The accident briefly severed her relationship with her mother and father. Both physically fragile people, Kahlo's parents were overwhelmed by the tragedy and could not see their daughter for twenty days. Kahlo would have been very lonely had it not been for her older sister Matilde, who lived nearby and stepped in to take care of her.

Matilde had been exiled from the Kahlo home for about eleven years for having eloped against her mother's wishes. Although Frida had had infrequent contact with her sister for a number of years, this was the first good amount of time she had spent in her company since she was a child.

Frida described Matilde as "fat and ugly," but with the ability to make people laugh. Matilde charmed all the people in the hospital while she sat by Frida's bed and both amused and guarded her. Sadly, the joy that Frida experienced at being reunited with her sister— even under the circumstances—was not to last. Once their parents arrived, Matilde was again banished. It was not until about 1927 that she was allowed to return to the family.

Kahlo left the hospital on December 18, but within a year it was discovered that her spine had not healed properly. The horrible pain that began with the accident was to stay with her for the rest of her life. It started at the hospital, she said, where "death dances around my bed."

Needless to say, hers was a very difficult recovery. For the remainder of her years, she was forced to wear a series of rigid corsets to support her broken spine, and she underwent many operations on her right foot in an effort to save it.

She could not return to the National Preparatory School, and spent lonely days at home. She asked her father, who had always amused himself with painting, if she could use his paints. Reluctantly, he agreed. She began with a number of portraits, self-portraits among them. These are folkloric-looking and formal, but do not reflect the surreal, *retablo*-like imagery she would later create under Rivera's influence. In one of her first self-portraits (1926), a young Kahlo looks out defiantly from under her now-famous eyebrows. She is wearing a plush, European-style dress of

crimson against a dark and indistinct background.

In 1927, Kahlo was up and about, although she was never again free of pain. Her ideas of becoming a doctor had disintegrated because of her ill health and the family's financial troubles. But while she had not been formally tutored in art, Kahlo's critical eye and meticulous draftsmanship gave her first attempts at painting a unique style. Of course, Kahlo had been drawing for a long time; her caricatures in letters and notes passed at the National Preparatory School were considered memorable, and she had been briefly apprenticed to an engraver, Fernando Ferranza (whom she also dated, to Arias' regret).

Although Kahlo made a sketch of the events surrounding her accident in 1926, it was a subject she never committed to painting. Instead, her fledgling efforts included the group portrait, *The Cachuchas* (1927), as well as individual portraits of her sisters Adriana (1927) and Cristina (1928) and her friends Miguel N. Lira and Alicia Galant (1927). In all of these portraits, Kahlo demonstrated an ability to capture resemblance. Her pictures showed real people.

A more fanciful painting is *La Adelita, Pancho Villa and Frida* (c. 1927). It is a charming picture in which the Mexican heroic icon Pancho Villa appears as a painting within a painting. Squares of activity are set at crazy angles, foreshadowing Kahlo's later, more unusual compositions.

Paintings such as these showed that Kahlo still enjoyed the youthful idealism she had shared with her friends, and for this reason she joined Mexico's Communist Party in 1928. It was there that she again saw Rivera. He was more well known than ever, and was a seminal figure in Mexico's politics.

RIVERA

Diego Rivera was a larger-than-life figure, both physically and in the context of Mexico's history. Although an avowed patriot, he was classically trained in European painting, and dabbled in several modern techniques, such as Cubism, before returning to Mexico to become one of its masters of mural painting. When he undertook his first mural at the National Preparatory School, he had just returned from living in Europe for fifteen years. He had had a Russian common-law wife, the painter Angelina Beloff, but

had married his mistress, Guadalupe "Lupe" Marin, after returning to Mexico. Their union had foundered due to Rivera's infidelity.

In fact, Rivera was never able to be faithful. Perhaps he enjoyed people's astonishment that a man of his physical characteristics could enjoy so many opportunities for intimacy with so many women. He was grossly fat for most of his life, and more than one person remarked that he resembled a frog. Be that as it may, he was always an inveterate ladies' man, a habit which would cause Frida many heartaches.

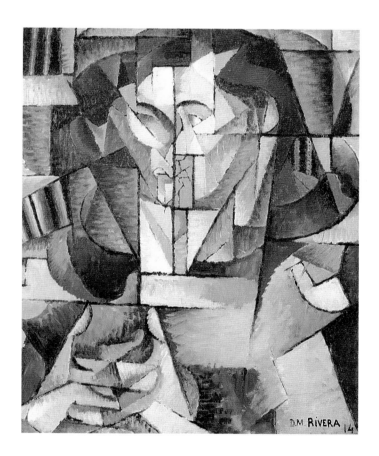

Jacques Lipschitz (Portrait of a Young Man)

DIEGO RIVERA; *1914; oil on canvas; 25½ x 21⅝ in. (65 x 55 cm).*

Gift of T. Catesby Jones, The Museum of Modern Art, New York.

Rivera was a European-trained artist, whose formative years were spent in France. Cubism was only one of the influences that inspired him; others were the works of El Greco and Goya.

But as a young girl at the Preparatoria, Kahlo had been obsessed by Rivera. She had spent hours watching him, playing tricks on him, goading him with unflattering nicknames. As an earnest young painter and Communist in 1928, she looked to him for approval. And he gave it to her.

According to Rivera, Kahlo accosted him while he was at work on *Liberation of the Peon* mural (1928) at Mexico City's Ministry of Education and challenged him to critique her paintings. Rivera pronounced them to be very good; whereupon Kahlo asked him to come to her house in Coyoacan and critique some more. At the time, Kahlo insisted that it was only Rivera's opinion she sought; although, with her earlier worship of him and her flirtatious personality, there was probably something else to it.

Surprisingly, Rivera was intrigued, and indeed went to Kahlo's house and critiqued her paintings. They struck up a relationship that quickly blossomed into love. Perhaps a key to their relationship was Kahlo's treatment of Rivera. She called him Diegelito, and often referred to him as her little boy. It must have intrigued the gargantuan painter that this doll-like creature could assume a maternal pose with him.

But if she pampered him as a doting mother would, she must also have associated him with her father. Twenty-one years older than she, Rivera was certainly old enough to be her father. And he shared certain characteristics with Guillermo, such as the fact that the lived in the world of ideas (in Rivera's case, the ideas were art and Communism). Like Guillermo, Rivera isolated himself from his family, preferring to work long hours, often until he collapsed. Of all his women, Kahlo perhaps most easily accepted and handled his physical collapses, as they likely reminded her of Guillermo's epileptic seizures.

By all accounts, Guillermo was accepting of Rivera, in spite of the difference between his and Frida's ages. Frida was his favorite daughter and he wished the best for her. He was concerned about her health (the medical demands resulting from the accident had overwhelmed the family's straitened finances), as well her precocity. He perceived that Rivera could serve well as an anchor in both circumstances.

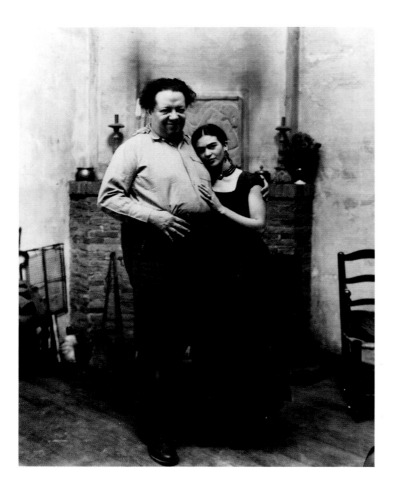

Frida and Diego in San Francisco

1930–31; photograph by Paul Juley, National Museum
of American Art, Smithsonian Institution, Washington, D.C.

As newlyweds, Rivera and Kahlo traveled to the United
States, where Diego's fame assured them celebrity
and prominence. However, problems were growing
that would cause great pain later, particularly for Kahlo.

Portrait of Virginia (Niña)

FRIDA KAHLO; *1929; oil on masonite; 33 x 26¾ in. (83.82 x 68.07 cm).*
Fundacion Dolores Olmedo, Mexico City.

This beautiful early portrait shows Kahlo's eye for detail.
Note the safety pin that holds the dress closed, while
delicate lace has been attached to the girl's sleeves.
Kahlo has given the girl her own "birdwing" eyebrows.

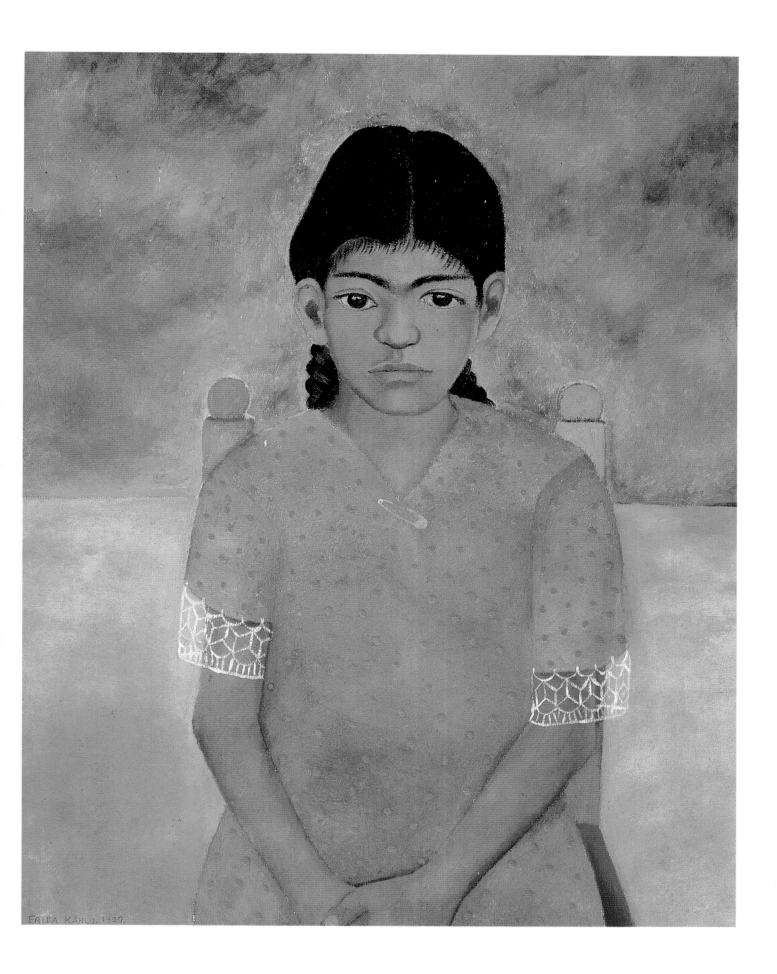

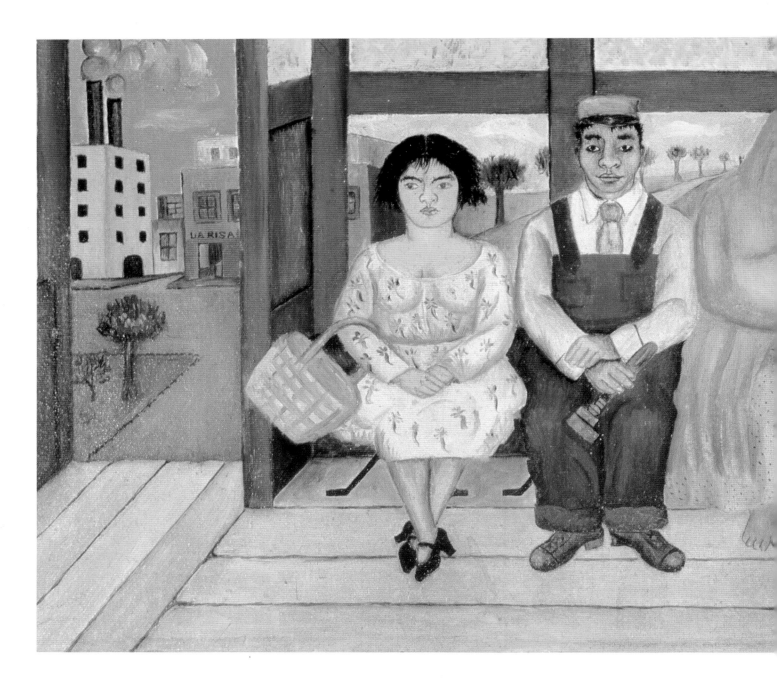

When there is a large disparity in the ages of lovers, expectations of both parties can be unrealistic. In *Voices of Mexico*, Rivera's daughter, Guadalupe Rivera Marin, reminisced that "neither handled married life as an adult, with adult responsibility. . . . They spoke of a very strong love, but it was a pretty infantile relationship; it wasn't the emotional giving of a couple that lovingly develops a sensual, sexual, passionate life."

Marin went on to say that Kahlo and Rivera "lived their own passions." At all times, however, Rivera was encouraging to Kahlo regarding her work. He inspired

her to find her own way, and not to paint as a European—which meant not to follow him, since that was, was, in truth, what he did.

And she responded in kind. In spite of all the betrayals, respect for each other's work characterized their relationship.

There was one change that Rivera wrought in Kahlo. He preferred her to dress in the Tehuana Indian manner, and she responded enthusiastically. For the rest of her life, she adopted Tehuana dress, which served the multiple purposes of being exotic,

The Bus

FRIDA KAHLO; *1929;*
oil on canvas; 10¼ x 22 in.
(26.03 x 55.88 cm).
Fundacion Dolores Olmedo,
Mexico City.
One of Kahlo's earliest
works, this painting
shows an assortment
of passengers, including
a blue-eyed capitalist
and a barefoot peasant.
The painting
demonstrates Rivera's
"heroic peasant"
influence. Kahlo nearly
lost her life in such a
bus five years before
this work was painted.

politically correct, and at the same time disguising her physical problems. Kahlo's exotic dress dominated the first impression most people had with her. Many people have said that she made herself into an art form.

Rivera's influence on Kahlo's early art was apparent in several of her paintings of 1929, including *The Bus*. One of Kahlo's earliest works, this painting shows nothing of the trepidation one would expect Kahlo to bring to a subject so tragic to her; instead, an assortment of passengers, including a blue-eyed capitalist and a barefoot peasant, coexist in colorful tranquillity.

Likewise, *Two Women* has some of Rivera's "heroic peasant" elements, although the lush tropical foliage would frequently recur in Kahlo's paintings. In *Portrait of Virginia (Niña)*, however, Kahlo's genius for capturing idiosyncratic detail is found in the safety pin that holds the young girl's dress closed.

Kahlo's *Self-Portrait* (1929), however, is unusually circumspect. While the trademark birdwing eyebrow is there, Kahlo herself seems indistinct. An airplane in the background appears as a concrete symbol of the journey on which she has embarked.

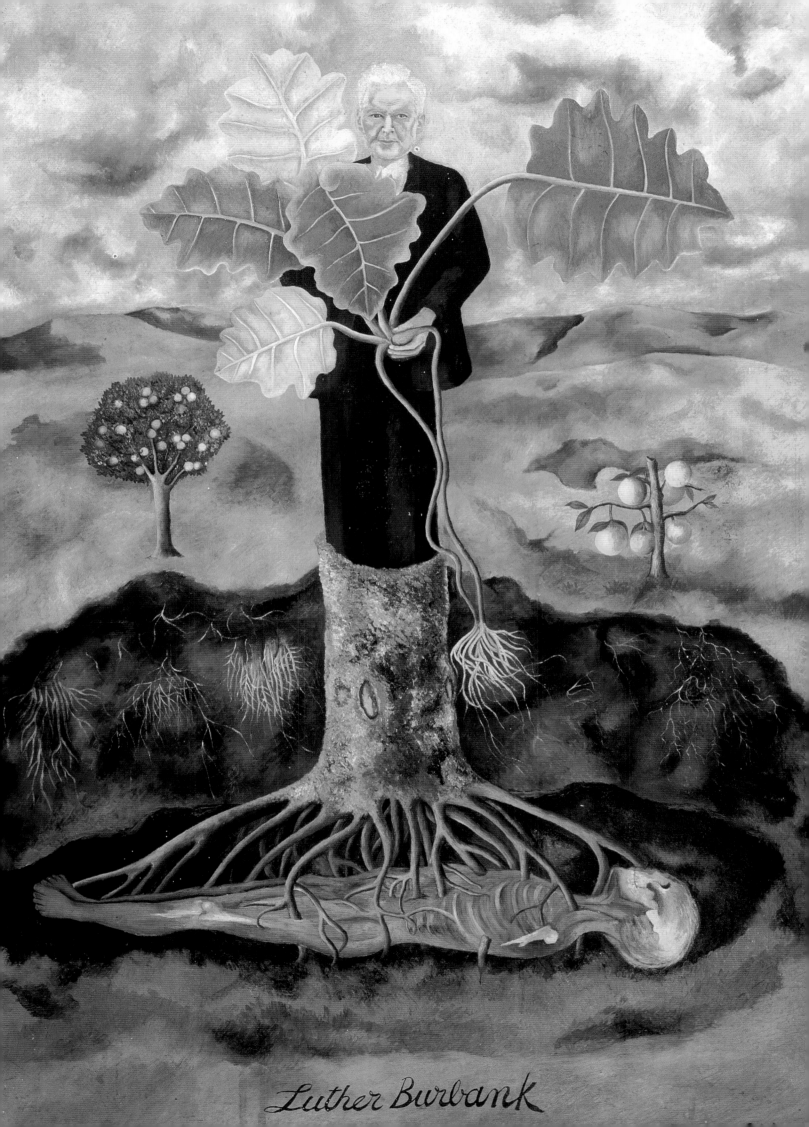

MARRIAGE

Rivera and Kahlo were married on August 21, 1929. Her mother did not attend, as the service was civil, but Guillermo was there, supporting the proceedings in his own way.

Immediately, Kahlo's life altered drastically. Not only was there the change of marriage, but she was the wife of a famous, important, and controversial individual. Rivera operated in the maelstrom of Mexican politics. He was world-famous, and everyone claimed him—not only the Mexican Communist Party, of which he was secretary general (until he "expelled" himself in 1929), but also Mexico's conservative government, which commissioned him to work on its behalf.

At first, Kahlo cut back on her own painting in order to be the perfect Mexican wife. If she did seek self-expression, it was through her rope of jewelry and her exotic Tehuana clothes of many colors. She did, in this year, sketch and paint several portraits, including one of Rivera's former wife, Lupe (with whom both Riveras maintained a close, if somewhat tempestuous, relationship), a self-portrait, and a draft for her 1931 painting *Frida and Diego Rivera*.

In 1930, Kahlo traveled with Rivera to San Francisco, where he accepted a commission to paint murals for the San Francisco Stock Exchange. Kahlo met many artists in San Francisco who later became her friends, such as Edward Weston. She was also enchanted with the Chinese section of San Francisco, and was particularly charmed by the little Chinese children. In turn, she was most often remembered by them for her exotic style of dress.

In San Francisco, she made the acquaintance of Dr. Leo Eloesser, whom she consulted regarding her various injuries and who became a close friend. Kahlo painted his portrait in 1931. Also in 1931, Rivera and Kahlo traveled to New York for an exhibition of Rivera's work to be held at the Museum of Modern Art. Kahlo enjoyed the city but felt somewhat adrift beside Rivera's enormous reputation.

Also in this year Kahlo painted several portraits. Some, such as *Portrait of Mrs. Jean Wight* and *Portrait of Lady Cristina Hastings*, were commissioned, others, such as Kahlo's sketches and portrait of Eva Frederick, appear to have been painted at her own initiative.

One portrait, however, represented a turning point in her art. The painting of the agriculturist Luther Burbank represents the scientist as a half-man, half-vegetable, receiving nourishment from his own corpse. This early narrative painting indicated that Kahlo was beginning to look beyond simple caricature and was refining her unique vision.

Another painting completed in 1931 was *Frida and Diego Rivera*, a wedding portrait. In this painting, Kahlo looks shy and diminutive in her Tehuana dress, while Rivera towers over her, with brush in hand.

Portrait of Luther Burbank

FRIDA KAHLO; *1931; oil on masonite;*
34½ x 24½ in. (87.63 x 62.23 cm).
Fundacion Dolores Olmedo, Mexico City.
This unusual portrait of Luther Burbank marks the origins of Kahlo's *retablo*, or narrative, style. The famous agriculturist is shown, like a plant, arising from his own death to bloom anew.

Portrait of Lady Cristina Hastings

FRIDA KAHLO; *1931;*
pencil on paper; 19 x 12¼ in.
(48.26 x 31.11 cm).
Fundacion Dolores Olmedo, Mexico City.
At the beginning of her career, Kahlo, overshadowed by Rivera, simply made portraits of the people she encountered. Although she would later reveal a very different vision, portraiture remained an important part of her artistry.

Frida Kahlo and Diego Rivera

1932; photograph by J. W. Settler,

The Detroit Institute of Arts, Detroit, Michigan.

Rivera, once embarked on a mural, would often paint
until he was near collapse. Kahlo had little opportunity to
spend time with him, except for the baskets of food she brought.

IN "GRINGOLANDIA"

Although Kahlo ultimately did not care for San
Francisco, those feelings were nothing compared to
the contempt and loathing she felt for the site of
Rivera's next commission, Detroit. Rivera, in love with
at least the idea of machinery (which, as a good
Communist, he believed would free humanity from
repetitive tasks), was excited to be painting a mural
that would reflect his admiration for the home of the
assembly line and for the inventor Henry Ford.

Kahlo thought Detroit was very ugly, and did not get
along with the people there. Nor did she apparently
make an effort; at a dinner party at Henry Ford's
house, she even asked Ford, knowing him to be a vir-
ulent anti-Semite, if he was Jewish.

Kahlo was lonely, since Rivera was always at work.
She painted *Showcase in Detroit* (1932), a charming
record of a storefront hodgepodge, and grew close to
and spent time with Rivera's assistant, Lucienne Bloch,
whom they had met in New York. But it was no substi-

tute for Diegelito. And she was ill. Not only that, con-
sulting a doctor about the deteriorating condition of her
right foot, she discovered that she was also pregnant.

Being pregnant awoke all kinds of fears in Kahlo.
She was afraid that her parents' tendency to epilepsy
(both Matilde and Guillermo experienced seizures)
would be inherited, and that her mangled torso could
not sustain a child. At first she attempted to abort the
fetus; when she remained pregnant, the doctor advised
her to carry to term, advising cesarean section for
when the time came.

It was not to be. She began to miscarry horrifically
during the night of July 4, 1932, and was taken to
Henry Ford Hospital, where she lost the child.
Strangely enough, the experience provoked one of her
few compliments about Detroit; as she was being
wheeled through the hospital, she looked up to see
ceiling pipes that had been painted red. These re-
minded her of the vivid colors of Mexico, and perhaps
figure in her painting *Henry Ford Hospital* (1932).

In Kahlo's painting, her hospital bed exists in a vac-
uum, beyond which the hated industrial apparatus of
Detroit can be seen in the distant background. She
holds ribbons, not unlike the red pipes of the hospital,
and they are attached to objects that each symbolize
some aspect of her miscarriage. There is the miscar-
ried fetus; a snail that represents the slow passage of
time during the pregnancy; and there are various real,
unreal, organic, and mechanical representations of the
pelvis that could not sustain life. Blood pools under
her body, and she is crying.

Like her *Portrait of Luther Burbank*, *Henry Ford
Hospital* is truly bizarre. In its naive composition and
complex symbolism, it closely resembles a *retablo*
painting. Only the saint is absent, because there is no
healing. Kahlo pursued this subject with *Frida and the
Miscarriage* (1932), which was her first attempt at
lithography.

Frida and the Miscarriage

FRIDA KAHLO; *1932; lithograph; 12¼ x 9¼ in.
(31.11 x 23.5 cm). Fundacion Dolores Olmedo, Mexico City.*
In her first lithograph, Kahlo tried to explain the
events leading up to her miscarriage. It is revealing that
the hand that holds the artist's palette is her "sick" side.

It was toward the end of 1932 that the health of Kahlo's mother took a turn for the worse. Unable to get a plane, Kahlo traveled from Detroit to Mexico City by train with Rivera's assistant Lucienne Bloch. It was an arduous journey, which offered much gloomy imagery to the disconsolate Kahlo, that she later assembled into *Self-Portrait on the Border, Line Between Mexico and the United States* (1932). In general, Kahlo had despised "Gringolandia." Arriving as she did during the start of the Great Depression, she felt that the gulf between rich and poor was too wide, and that many seemed unconcerned about it. Considering herself a child of the Revolution, it was inconceivable to her that there were people who gave so little thought to politics and justice.

By the time she arrived in Coyoacan, all her sisters were assembled, including Matilde, who had been forgiven several years before. It was not an easy death, however; their mother was in too much pain to speak. She finally died on September 15, 1932. Kahlo cried for days, her ambivalent relationship with El Jefe having ended without closure.

Kahlo attempted to heal the breach by painting *My Birth* (1932), in which her mother, covered like a corpse except for her naked pudenda, is giving birth to an enormous infant Frida. The Mater Dolorosa looks on from a painting on the wall.

Afterward Kahlo returned to America to be with Rivera, but it gave her scant comfort, as the Riveras' troubles in "Gringolandia" were mounting. Although Kahlo was of European descent on her father's side and had received the best education Mexico had to offer, this journey with Rivera was her first outside of Mexico. Rivera, on the other hand, was a cosmopolite, having lived in France for many years. He felt

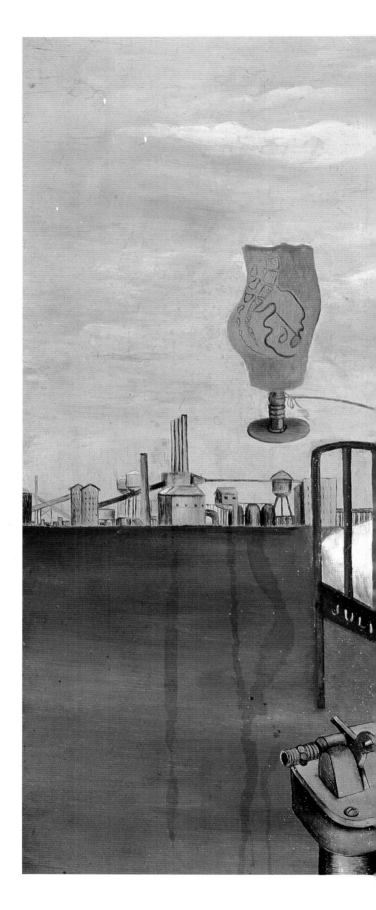

Henry Ford Hospital

FRIDA KAHLO; *1932; pencil on paper; 5½. x 8¼ in. (14 x 20.82 cm). Fundacion Dolores Olmedo, Mexico City.* Kahlo's hospital bed exists on a desolate plain, where the industrial apparatus of Detroit can be seen in the distant background. In her hand are ribbons attached to objects that each symbolize some aspect of her miscarriage.

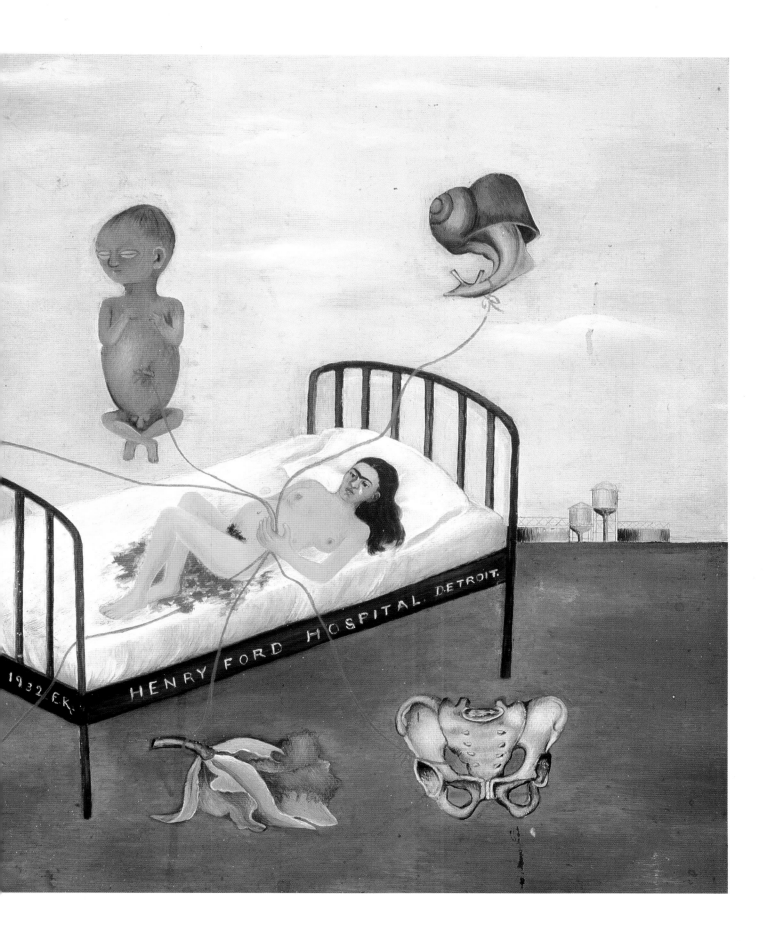

extremely at ease in the land of the gringos. They lionized him, as befitting a great artist, and he received extremely valuable commissions that not only enriched him but enhanced his reputation.

After Detroit, Rivera and Kahlo traveled to New York City, where Rivera had accepted a commission to paint murals in the halls at Rockefeller Center. While she disliked New York City very much (she painted *My Dress Hangs There* as a sly send-up of the city's superficiality) Kahlo found it considerably more diverting than Detroit and became very active. As usual, wherever she went, her Tehuana costumes attracted both attention and admiration.

The Rockefeller commission, controversial from the beginning, turned into a rout when Rivera insisted on

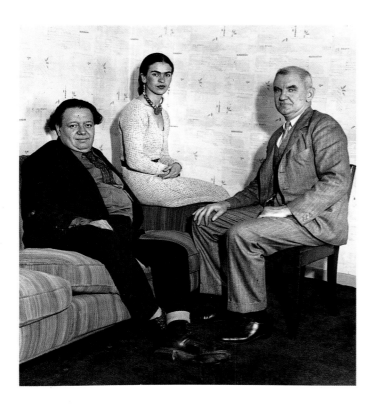

The Riveras and A. Conger Goodyear

1931; archival photograph. Bettmann Archives.

In 1931, Rivera and Kahlo traveled to New York for an exhibition of Rivera's work to be held at the Museum of Modern Art. Here, they meet with A. Conger Goodyear, president of the museum, who was later to became a patron of Kahlo's as well.

painting Lenin's face on the walls. Rivera was summarily fired, and the mural covered up. Although Rivera was eventually able to realize his vision in a replicated mural in Mexico City, New York had suddenly turned into a very cold place for the Riveras. Rivera defiantly spent his entire Rockefeller commission decorating the walls of the New Workers School. A group of artists, Louise Nevelson among them, had to organize a fund that would help the Riveras return to Mexico.

RETURN TO MEXICO

The protracted stay in "Gringolandia," the miscarriage, the physical breakdowns of both partners, Rivera's affairs, misunderstandings, the death of Kahlo's mother and the estrangement from loved ones in general, and Mexico in particular began to affect the couple. Perhaps their life together had been too full of excitement for them to get used to one another. The Rockefeller debacle did nothing to soothe Rivera's "star" temperament, and the prospect of returning to Mexico, where his every move would be questioned, criticized, and politicized, probably did nothing for his humor. Rivera's expulsion from the Communist Party, even if he had orchestrated it himself, rankled.

Kahlo's right foot was still bothering her, and she needed an operation in 1934. By this time, Kahlo was also being hurt by Rivera's many affairs. Although she knew of his nature (she in fact had set his girlfriends against each other while at school), she was probably dismayed to find that she, too, could become his unwilling victim.

In 1934, the Riveras moved into the San Angel district of Mexico City. An unusual space had been designed for them by their friend, the architect Juan O'Gorman, which consisted of two separate houses joined by a bridge along the second-floor terrace. Rivera's was the larger house, where the guests whom he wished to impress were invited and where formal entertaining was done. Kahlo's house was smaller and more private. However, their idyll came to an end almost as soon as it had started when Rivera began his affair with Kahlo's younger sister, Cristina.

What possessed the adulterers no one can truly say. The affair had a particularly destructive quality for Frida, as she was intensely fond of Cristina. Perhaps

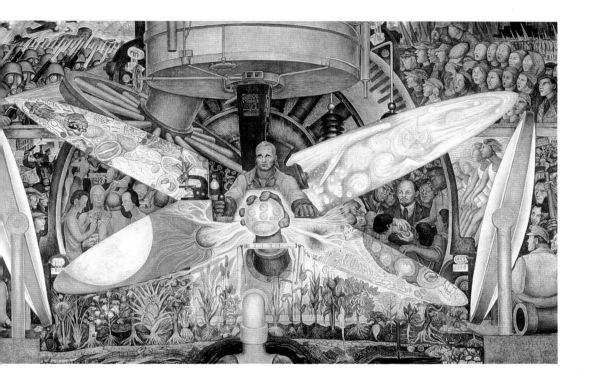

Man, Controller of the Universe (Man in the Time Machine)

DIEGO RIVERA; *1934; fresco. Museo del Palacio de Bellas Artes, Mexico City.*

This is the mural that was to have adorned the walls of Rockefeller Center. Nelson Rockefeller, objecting to the prominent portrait of Lenin on the right, fired Rivera and ordered the mural destroyed. Rivera later recreated it in Mexico.

she felt that Rivera had struck this blow in a personal way, that he resented her assertiveness (or even her illness), and that while he liked some things about her, these he could find in a less inconvenient form through Cristina.

Rivera portrayed both Cristina and Frida in his mural *Mexico, Today and Tomorrow* at the National Palace, which he began in November of 1934 and completed in 1935. In the mural, Cristina is portrayed as conventionally (and exceedingly attractively) feminine; she is surrounded by her children, Isolda and Antonio. In contrast, Frida is dressed in boy's clothes and positioned behind her sister. This composition led some to speculate that Kahlo would terminate their marriage, since Rivera also placed his former wife, Lupe Marin, and mistress Tina Modotti in the work.

The juxtaposition of the sisters was cruel to both. Cristina had what Frida lacked, which was health and fertility. She had had two children, whom Frida loved and showered with an aunt's devotion. Frida, on the hand, had truly won Rivera, despite her poor health; her inability to bear children was never an issue with him, however guilty she felt about it.

But Cristina lacked Frida's wit and intelligence, and

this was the true basis for his attraction to Frida. However, a roving eye and perhaps unconscious spite at being in Mexico again after the disappointment of the United States had started Rivera moving in Cristina's direction. He remained Cristina's financial protector well after their affair was over.

Whatever the reasoning, Frida took the betrayal keenly. To her, it was the ultimate betrayal. She felt a sense of disillusionment from which she never truly recovered. In her despair, she cut off all her hair—a traditional method of women's mourning of which Kahlo was surely aware. As she had as an outrageous young girl, she began to dress in men's clothes, as if she were disassociating herself from her feminine side.

But in a larger sense, Rivera's betrayal of Kahlo also set her free. It showed her that a traditional relationship, whereby she subjugated her desires and needs to his, would not work, because he did not value sacrifices of that nature. Rivera's betrayal was a kind of psychic surgery; it removed the final impediments to her progress as an artist. Unshackled by conformity, she was able, during the next decade, to fulfill the realization of her sexuality and her artistic vision. Fame would come, too.

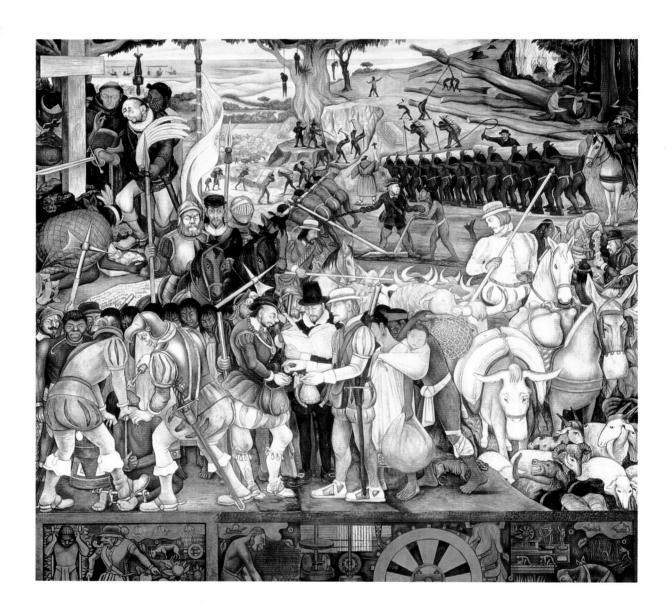

The Conquest of Mexico

DIEGO RIVERA; *1929–30; fresco. National Palace, Mexico City.*
Here, the conquistadors, priests, and their attendants take up
the foreground, while the native Indians and their misery
are shunted to the back. Rivera's composition (which owes much
to European artistic tradition) is telling the story of power.

The Aztec World

DIEGO RIVERA; *1929; fresco.*
National Palace, Mexico City.
Here, Rivera portrays a
peaceful, agrarian society.
Although the colors might be
taken from an ancient mural,
the perspective through the
fields and avenues receding
into the distance is a product
of Rivera's European training.

Head (Cabeza)

FRIDA KAHLO; *n.d.; oil on canvas. Fundacion Dolores Olmedo, Mexico City.*
A militant self-portrait gazes sternly from
this rough, undated sketch, which also includes
an unfinished easel floating in the space above.

Ady Weber

FRIDA KAHLO; *1930; drawing. Fundacion Dolores Olmedo, Mexico City.*

Kahlo has captured a dancer's body in this sketch reminiscent
of Modigliani; note the elongated frame and exaggeratedly small
breasts. Weber's feet are placed within the picture, almost *retablo*-style.

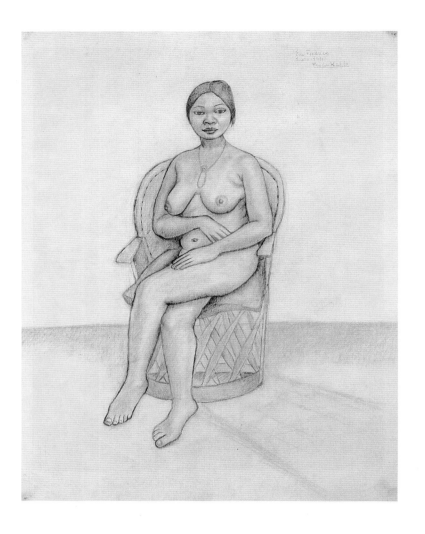

Nude of Eva Frederick

FRIDA KAHLO; *1931; pencil on paper; 24¹/₃ x 18³/₄ in.*
(61.97 x 47.75 cm). Fundacion Dolores Olmedo, Mexico City.
This pencil sketch of Eva Frederick shows that
Kahlo had an excellent command of conventional
drawing, if not a complete grasp of perspective.

Portrait of Eva Frederick

FRIDA KAHLO; *1931; oil on canvas;*
24³/₄ x 18¹/₂ in. (62.86 x 47 cm).
Fundacion Dolores Olmedo, Mexico City.
This portrait, painted while Kahlo
and Rivera were in New York,
shows the beginnings of Kahlo's
folkloric style. The banner, which
frames the subject's head like
a pair of wings, proclaims the
portrait's location and intention.

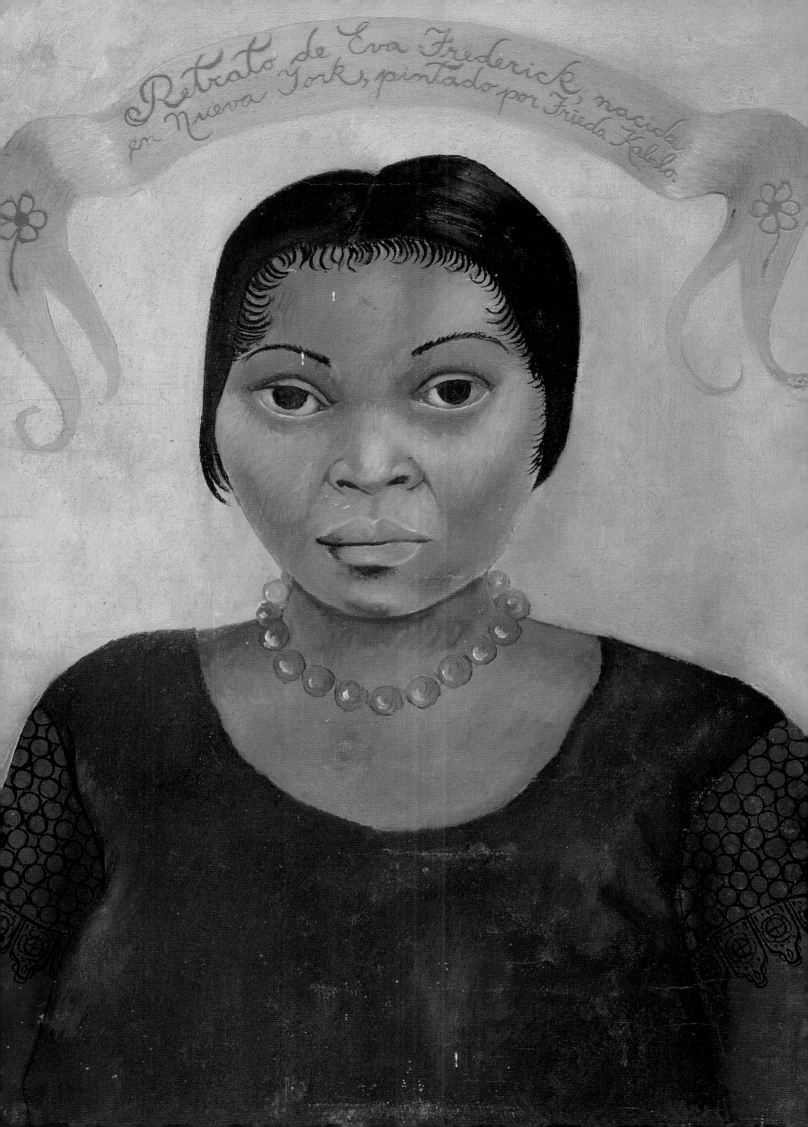

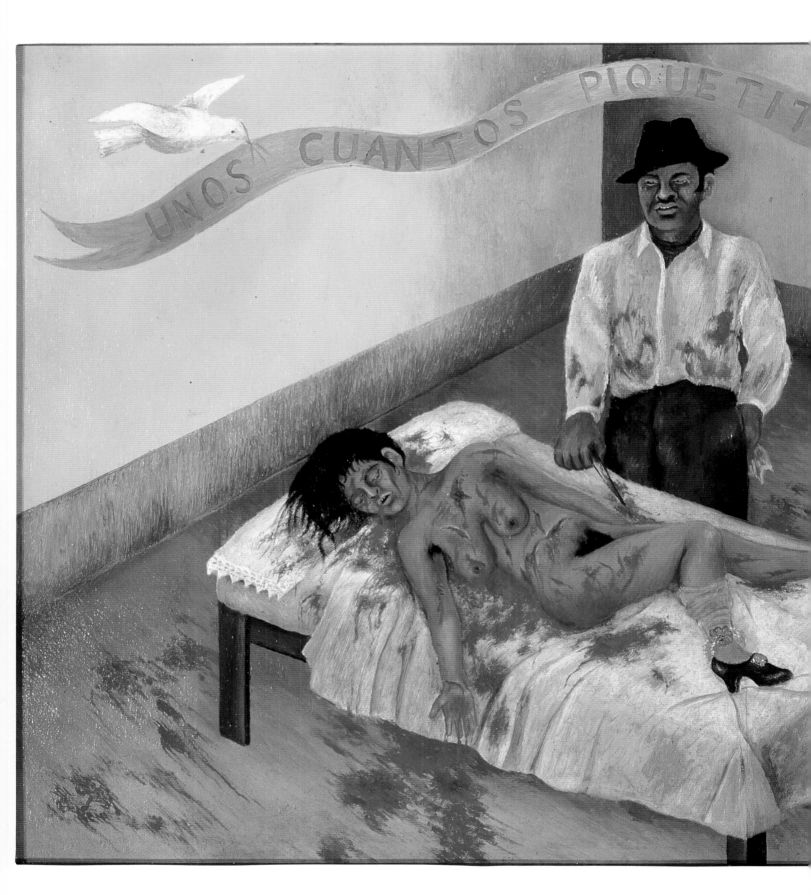

ADVENTURES AND RECONCILIATIONS 1935–1941

The constant betrayals of her husband were to have a lasting impact on Kahlo, and from the intensity of her emotions she would draw the inspiration that helped her create her greatest work.

SEPARATION

Separating from Rivera due to his ongoing relationship with Cristina, Kahlo moved out of San Angel and into a small apartment on the Avenida Insurgentes, on the other side of town. The apartment happened to be across from a gas station. One day she was dismayed to see Cristina filling up her tank there. Perhaps Cristina wanted to make amends. In time, the sisters would become friends again, and Cristina would become not only Frida's confidante, but an accessory in her own affairs.

Meanwhile, in her anguish, Kahlo turned to art. Telling of her rage and talent is a painting entitled *A Few Small Nips* (1935). A gruesome account of a murder was then in the newspaper: A man had killed his girlfriend in a drunken spree, stabbing her twenty times. Called to account, the man insisted that all he had done was give her "a few small nips."

This sordid tale became the basis for one of Kahlo's most well-known works. In the painting, a disheveled female corpse is displayed in an attitude of abandon, while it bleeds from several punctures. The murderer looks down at the body, blade in hand,

A Few Small Nips

FRIDA KAHLO; *1935; oil on metal; 15 x 19 in. (38.1 x 48.26 cm). Fundacion Dolores Olmedo, Mexico City.*
A grisly murder is recounted within a blood-daubed frame; above, a gay
banner proclaims that the mutilated woman has received only "a few small nips."
Kahlo used this allegory to describe the pain Rivera's betrayal caused her.

while above, a gay banner proclaims that the mutilated woman has received only "a few small nips." The veracity of the banner is belied by the gory blood that is spilled throughout the painting, even splashing the picture frame.

The painting recalls the work of Jose Guadalupe

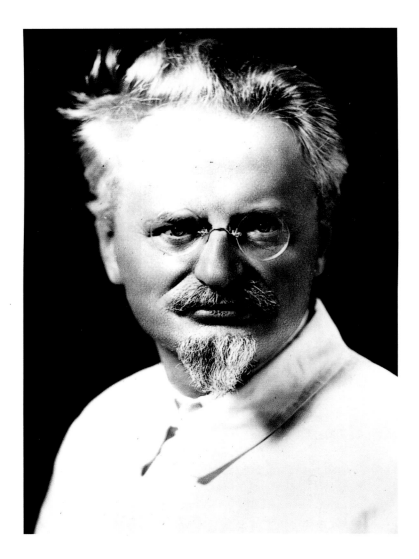

Trotsky

1937; archival photograph. UPI/Corbis-Bettmann.

Rivera had promised refuge to Leon Trotsky in Mexico, a promise he kept for many years, even after they quarreled. When Trotsky was murdered in 1940, both Kahlo and her sister Cristina were grilled by police for hours, since the assassin had been known to them.

Posada, in particular his 1890 engraving portraying a notorious murderer of women slitting the throat of a victim. It also typifies the *retablo*-esque style that was beginning to characterize Kahlo's vision. As in a *retablo*, the cause of the illness is revealed—i.e., the man with the knife. For Kahlo, the wounding is caused by Rivera's infidelity. The banner, which attempts to belittle the act, symbolizes his irresponsible attitude.

According to Kahlo's biographer Hayden Herrera, *A Few Small Nips* helped the artist recover her equilibrium, so that she was able to forgive Cristina and Rivera somewhat. And she had learned much, discovering—the hard way—that Rivera would never be true to her. This, in turn, helped her come to the conclusion that what was good for the gander was good for the goose as well. It was at this time that Kahlo began to explore relationships with both men and women. She began to have affairs herself.

As would become more apparent in future years, Kahlo had a talent for picking lovers who would, in time, enhance her own mystique; her taste included well-known artists and statesmen. Her first recorded extramarital affairs were with the artist and novelist Ignacio Aguirre, who described her as "scandalously beautiful," and the sculptor Isamu Noguchi. Noguchi (1904–88) was living in Mexico at the time on a Guggenheim grant, and working side by side with Rivera while painting the Mercado Rodriguez murals.

Kahlo's affair with Noguchi was short but passionate; the young couple had assignations wherever they could, including Cristina's apartment. Whenever they met, however, they were in fear of encountering Rivera and his famous gun. While Rivera appeared to countenance Kahlo's affairs involving women, he wanted no male rival for her affections.

Kahlo's health continued to trouble her. In 1936, she again underwent surgery at the American British Cowdray Hospital (called ABC) in Mexico City. Hospitals like Henry Ford and ABC would become a recurring motif in Kahlo's later paintings, since they had become a part of her everyday reality.



TROTSKY'S ARRIVAL

Meanwhile, Rivera, still an outspoken Communist if no longer an actual Party member, was engaged in bringing one of the fathers of the Russian Revolution, Leon Trotsky (1879–1940), to Mexico.

Rivera had joined the Fourth Internationale, a Trotskyite organization with which he had become acquainted in New York. Following Lenin's death in 1924 and Stalin's assumption of power, Trotsky had been accused of treachery and forced to leave Russia. Since his departure, he had led a peripatetic existence with his wife, Natalia, fleeing Stalinist zealots who longed for his head and various host countries as they became too dangerous.

Rivera promised Trotsky refuge in Mexico, a nation that appeared (at first glance) to lie outside the grasp of Stalinist Russia. On January 9, 1937, Trotsky, his wife, Natalia, and his assistant, Jean van Heijenoort, arrived in Tampico aboard the oil tanker *Ruth*. Threats against Trotsky's person had reached such a level that he refused to leave the ship until he saw "friends."

Waiting to greet Trotsky were Max Schachtman, the leader of the American Communist Committee, and Frida Kahlo, who was standing in for Rivera, who was then in the hospital. The Trotskys were taken to Kahlo's parents' house in Coyoacan, where they were greeted by a party of family members and guests, including a bemused Guillermo, who demanded to know who they were.

Kahlo, who had been reading revolutionary works since she was a young girl and had always been attracted by accomplished older men, was certainly fascinated by Trotsky and sought to ensnare him with her flirtatious manner. The revolutionary, who himself had a roving eye, reciprocated in kind. They had a brief affair, knowledge of which was hidden from Rivera, although Trotsky's wife seemed to glean what was going on.

After a time, Kahlo and Trotsky seemed to part amicably, Kahlo painting for him one of her "charming" self-portraits, this time in Western dress. This was probably a tongue-in-cheek gibe from Kahlo, since one of her complaints regarding Trotsky was his Old World conservatism, demonstrated by his objecting to her smoking and other signs of unladylike rebellion. It was this portrait that André Breton saw while visiting

Trotsky Arrives in Mexico

1937; archival photograph. UPI/Bettmann.

At the invitation of Rivera, Leon Trotsky and his wife, Natalia, arrived in Tampico, Mexico, in January of 1937. They were met by Max Schachtman, leader of the American Communist Committee, and by Kahlo, who stood in for her husband.

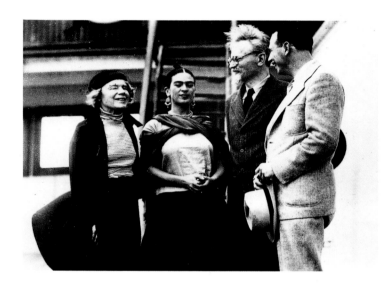

Trotsky in April of 1938, and it would lead him to claim Kahlo as a fellow Surrealist.

MOVING INTO RECOGNITION

The year 1937 was indeed a prolific year for Kahlo, during which she painted several of her masterpieces. These included *My Nurse and I*, a startling self-portrait in which Kahlo revisits her infancy, when she was breastfed by a young peasant woman. Instead of an infant, however, Kahlo is depicted as an adult with a dwarfish body. In the painting, the young nurse's face is covered by a mask, which changes her into some kind of pre-Columbian monster. The infant Kahlo is drinking the milk of this personification of Mexico with a satisfied, almost drugged look. The milk appears visible within the breast, curling and delicate like the tendrils of a fern.

Kahlo also painted other pictures that dealt with the subject of childhood. One, *The Deceased Dimas Rosas* (1937), was a straightforward "remembrance" portrait of a dead child. The young Dimas was the son of one of Rivera's *compadres*; the father had relied on a num-

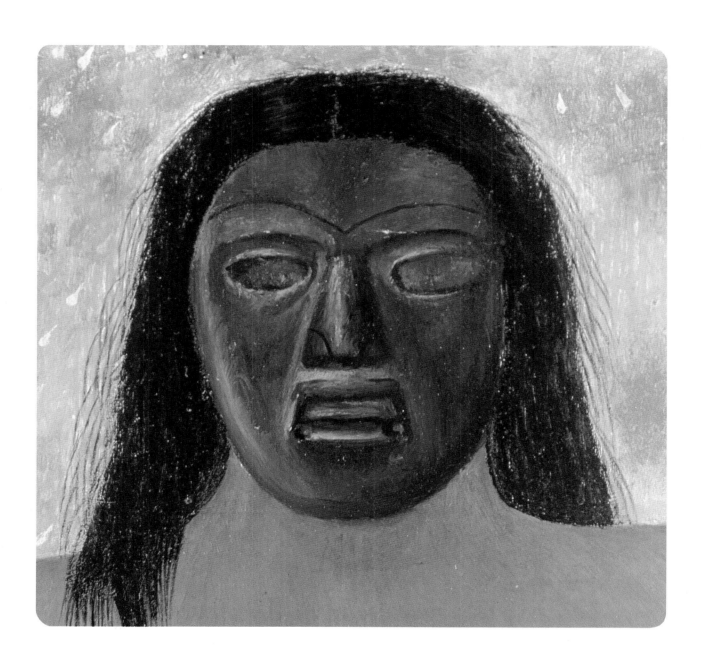

My Nurse and I

FRIDA KAHLO; *detail; 1937; oil on metal.*
Fundacion Dolores Olmedo, Mexico City.

As a child, Kahlo had been breastfed by a peasant woman of whom she remembered little. In her rendering of the nurse, the woman's face has become a mask with pre-Columbian significance.

Cihuateteo Figure

Pre-Columbian, A.D. 1300–1521; stone sculpture. British Museum.

A cihuateteo is the malevolent spirit of a woman who has died giving birth. Kahlo, who was familiar with pre-Columbian sculpture, may have had this in mind when she painted *My Nurse and I.*

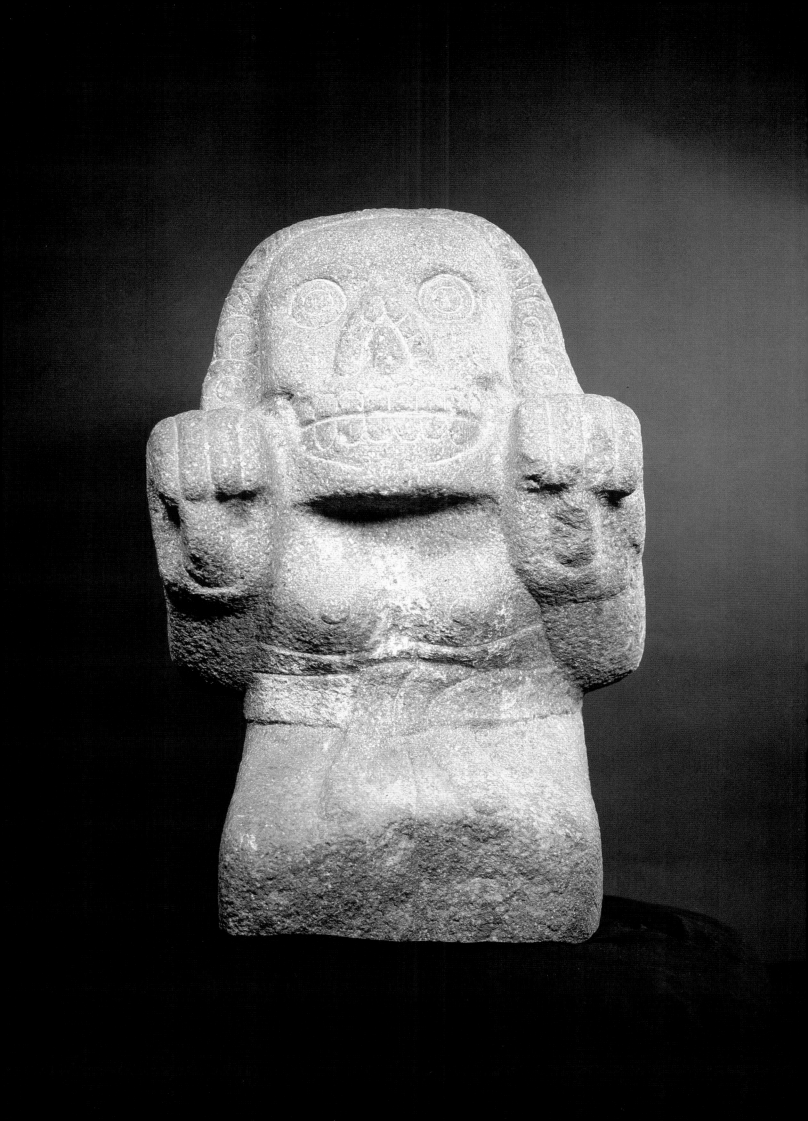

ber of folk remedies for the sick child when both Riveras felt the boy would have responded to modern medical attention. It is a "face of death" portrait that Kahlo made excruciatingly painful with sadness. *The Deceased Dimas Rosas* would later be more than equaled by Kahlo's equally disturbing *Suicide of Dorothy Hale* (1939).

Me and My Doll (1937) recorded a more personal loss, that of her unborn child Kahlo had a multitude of dolls, on which she lavished her maternal affection. In this painting, she is seated on a hospital-like bed with a European-style doll the size of a human infant. Kahlo is smoking, a habit she frequently captured in her paintings, as with *Itzcuintli Dog with Me* (1938). Perhaps the cigarette is meant as an act of defiance, or maybe it is meant to shield Kahlo from the pain of frustrated motherhood.

In addition to dolls, Kahlo also had many beloved pets, including the monkey Fulang-Chang (a name that means "any old monkey"), whom she included in the self-portrait *Fulang-Chang and Me* (1937). Several monkeys, talking birds, and other animals were to be found at different times in Kahlo's home, where they frequently entertained guests with their antics. Even if they misbehaved, as occasionally happened, they still received the unconditional love of both Kahlo and Rivera.

Among Kahlo's less lighthearted self-portraits is *Memory*. There, Kahlo shows herself transfixed by a long pole, recalling the accident that changed her life; or she may be recalling her second "accident"— Rivera—and his infidelity, which continued to wound her. To her left is a child's costume, representing the schoolgirl for whom the adult Kahlo has grown out of reach, and on her right is one of her Tehuana costumes, representing Rivera's influence. On the ground lies an enormous heart. All of these disturbing elements are bound together in a dreamscape.

In addition to these works and some self-portraits, Kahlo also painted other portraits that year, including one of her accountant, Alberto Misrachi, and a conventional likeness of Rivera.

It was in 1937 that Kahlo gave the first public exhibition of her work. *My Parents, My Grandparents and I*, painted the year before, was exhibited in a group exhibition at the Social Action Department Gallery of the University of Mexico. It drew considerable attention and prompted public discovery of Frida Kahlo as an artist in her own right. The exhibit led to her first one-woman show at the Julien Levy Gallery in New York, held in the latter part of 1938.

At this time, she met Nicholas Muray, a Hungarian photographer who was visiting Mexico City. They began an affair, which was renewed when Kahlo visited New York for her exhibition at the Julien Levy Gallery. It was one of Kahlo's more serious affairs and she shared a great deal of her thoughts with Muray in the letters she sent from France. But although Muray cared for Kahlo, his passion was less than hers. She would be greatly distraught when, back in New York from France, she discovered that he was about to marry another woman.

In 1938, Kahlo sold her first paintings to none other than the American actor and art connoisseur Edward G. Robinson. Robinson, in Mexico City visiting Rivera's studio, was shown Kahlo's work by Rivera, and bought four paintings for eight hundred dollars.

Kahlo continued to mine the feelings brought on by her physical and mental woes. She painted *Self-Portrait with Bandaged Foot* and *Remembrance of an Open Wound*. In *Self-Portrait with Bandaged Foot*,

Fulang-Chang and Me

FRIDA KAHLO; *1937; oil on composition board; 15¾ x 11 in. (40 x 28 cm).*
Gift of Mary Sklar, The Museum of Modern Art, New York.
Kahlo lavished her frustrated maternal feelings on a
number of pets, including this one—whose name means
"any old monkey." This portrait was a hit at Kahlo's
one-woman show at New York's Julien Levy Gallery.

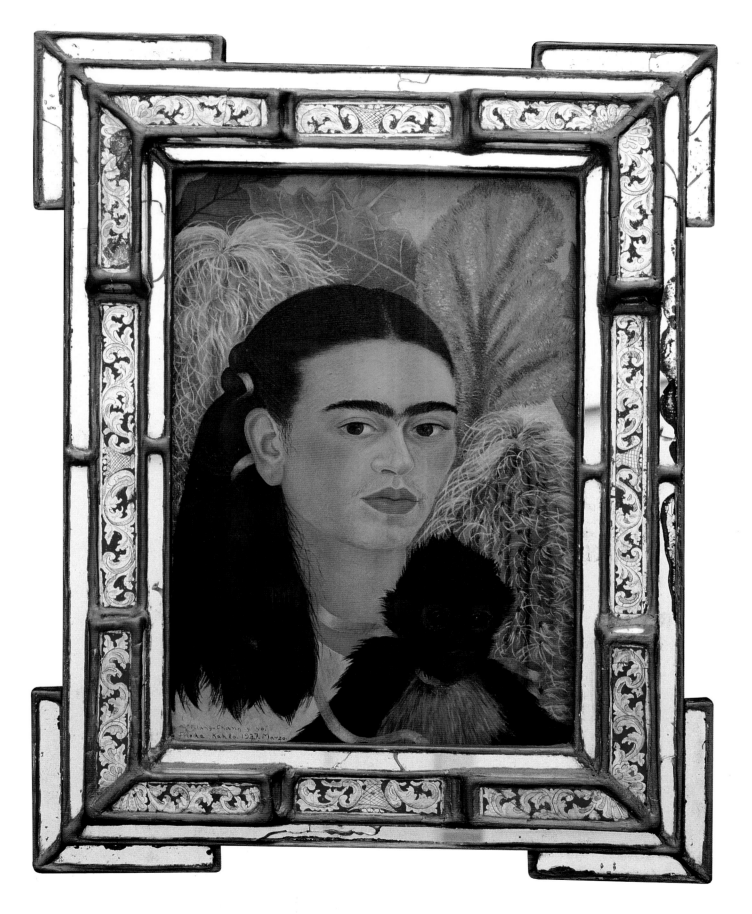

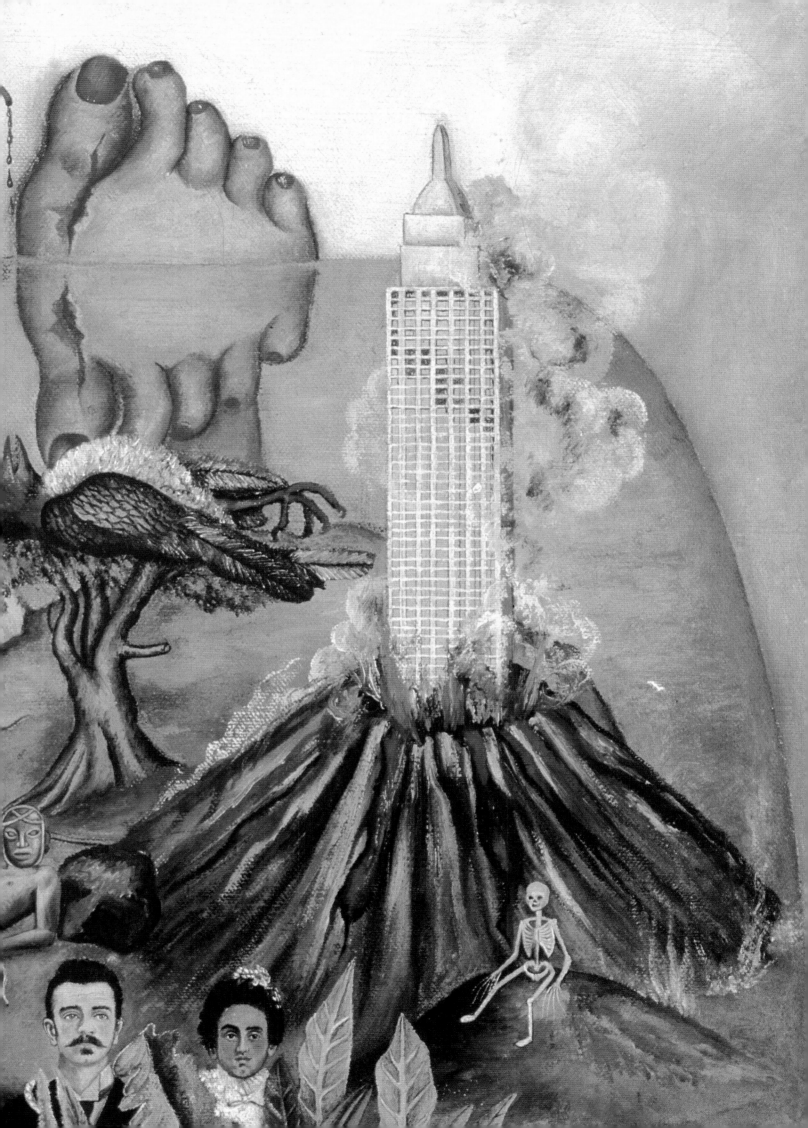

Kahlo's right foot is extended and bleeding through its bandage. The deterioration of the foot was a constant source of anguish to Kahlo, who labored mightily to avoid amputation. (In the end, this avoidance probably killed her.) In Kahlo's paintings, however, physical pain was also coupled with the psychic variety, for although Rivera was continually appreciative and supportive of his wife's work, and loved her wit and humor, these qualities were simply not enough to still his roving eye.

On some level, Kahlo understood how bittersweet her situation was. In *Pitahayas* (1938), for example, Kahlo combines in a still life the disturbing elements of eroticism and corruption. The overripeness of the fruit simultaneously refers to the moral consequences of passion as well as to her own wounded body. The tiny skeleton, a *memento mori*, underscores the gloom. More blatantly erotic were *Fruits of the Earth*, *Tunas (Still Life with Prickly Pear Fruit)*, and *Flower of Life*, all painted the same year.

A NEW WORLD SURREALIST

Around this time, Kahlo met André Breton (1896–1966), who had been so impressed with the self-portrait of Kahlo's he had seen while visiting Trotsky. Breton annoyed Kahlo considerably by attaching her

What the Water Gave Me

FRIDA KAHLO; *detail; 1938; oil on canvas. Private collection.*

André Breton claimed Kahlo as a member of the Surrealist movement, but she rejected Surrealism as a European overlay. Yet the conflict between the realism and magic of Mexico and the European orientation was found even within herself— as shown especially in *The Two Fridas*, but also here, as a skyscraper emerges from the bowels of an erupting volcano, the Old World giving birth to the New among symbols of death and destruction. Is the tiny skeleton Kahlo's own—placed near the figures of her parents—or is it her stillborn child, lost in the mechanized and sterile landscape of "Gringolandia"?

name to the Surrealist movement, a European concept with which she had little patience. She preferred to think of herself as an original.

But as far as Breton was concerned, Kahlo's reputation was sealed with *Four Inhabitants of Mexico* and *What the Water Gave Me*, both painted in 1938. In what Breton considered brilliantly surreal works, Kahlo used disjointed imagery to construct a narrative. In the case of *Four Inhabitants of Mexico*, the narrative is political in intent. The four inhabitants in question are a Judas figure, a little girl, a pre-Columbian idol, and a skeleton. In the background, there is another figure, a piñata. Three of the figures are celebratory, one represents the old Mexico, and one the new Mexico. Two of the figures, the Judas and the skeleton, would reappear in *The Wounded Table* (1940).

Four Inhabitants of Mexico may be contrasted with the less playful *Girl with Death Mask*, painted the same year. In this painting, a little girl is holding a skull-like mask to her face, while another mask lies at her bare feet.

In *What the Water Gave Me*, Kahlo's stream-of-consciousness daydreams are captured in her bath water. Kahlo's mind wanders through various visions, including her parents' wedding, her own Tehuana costume, and images of love and death. *What the Water Gave Me* is a window into Kahlo's mind, blending her unique talent for naive rendering with a dreamscape that could mean, like the images of the mind, many things simultaneously.

Later, Kahlo extracted the women floating on a sponge and gave them their own painting, entitled *Two Nudes in the Jungle* (1939). The quiet but lush beauty of the reclining figure and the jungle background is evocative of Rousseau, but the erotic message is very much a part of Kahlo. The painting is inviting and full of organic textures, unlike the desolate plateaus that frequently heralded her quarrels with Rivera. Kahlo gave the painting to the film star Dolores Del Rio, who was a family friend.

Self-Portrait with Monkey

FRIDA KAHLO; *1938; oil on masonite; 16 x 12 in. (40.64 x 30.48 cm). Bequest of A. Conger Goodyear, 1966, Albright-Knox Art Gallery, Buffalo, New York.* This portrait, similar to *Fulang-Chang and Me*, was painted to order. A. Conger Goodyear had wanted to purchase the earlier portrait but Kahlo had already presented it to Mary Sklar.

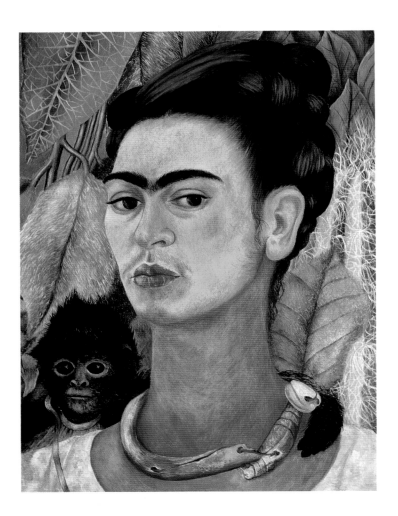

"THE SUICIDE OF DOROTHY HALE"

In late 1938, Kahlo went to New York to attend her first one-woman show at the Julien Levy Gallery. Her paintings were very well received, particularly *Fulang-Chang and Me*, which was a tremendous hit. A. Conger Goodyear, the president of the Museum of Modern Art, whom Frida had met with Rivera in 1931, wanted the painting badly. Upon learning that Kahlo had given it away, he commissioned another, which she completed before she left. Her *Self-Portrait with*

Monkey (1938) was to be the first of many replicas; as Kahlo had discovered, it was a commercially viable motif.

Still, Kahlo had yet to hone her commercial instincts, or learn how to occasionally subordinate her artistic vision to her patrons' need for decoration. One of her most interesting and telling faux pas was *The Suicide of Dorothy Hale* (1939). According to the playwright Clare Boothe Luce, Kahlo had approached her about doing a "remembrance" of Hale. Luce, wishing to present her dead friend's mother with a memorial portrait, agreed to commission Kahlo.

The resulting portrait was unlike anything Luce might have expected in her wildest dreams. As in *The Deceased Dimas Rosas*, Hale's face of death stares out of the portrait. But more than that, the physical circumstances surrounding her suicide—the skyscraper, the fall through air, the landing, the splashes of blood, and, finally, death—are all present. The images set down by Kahlo are immediate and arresting. The painting is so well realized that it is almost like watching the film of an actual suicide.

The Suicide of Dorothy Hale is a masterpiece, and yet it went unseen for decades. Luce, not wanting to lay eyes on it again, immediately gave the painting to her friend, Frank Crowninshield, for safekeeping. It was returned years later by Crowninshield's son, following the death of his father.

"MEXIQUE"

In 1939, Kahlo went to Paris for Breton's exhibition "Mexique." Breton had wanted to give Kahlo an exhibition in Paris. It was an idea she did not scorn, and had sent eighteen paintings over for the purpose. When she arrived, she found that nothing had been

The Suicide of Dorothy Hale

FRIDA KAHLO; *1939; oil on masonite; 23¼ x 19 in. (59.05 x 48.26 cm). Gift of an anonymous donor, Phoenix Art Museum, Phoenix, Arizona.* This painting represents a misunderstanding between Kahlo and Clare Boothe Luce that turned into something of a black comedy. Luce, wishing to present her friend's mother with a memorial portrait, commissioned Kahlo, who produced instead this breathtakingly tragic work.

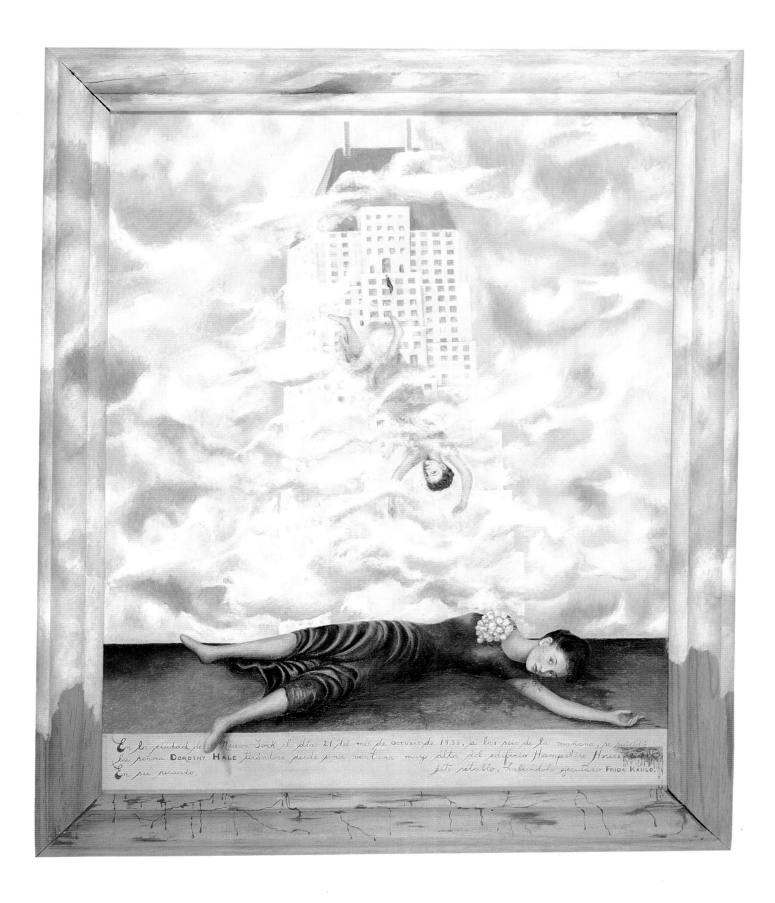

En la ciudad de Nueva York el día 21 del mes de Octubre de 1938, a las seis de la mañana, se suicidó la señora DOROTHY HALE tirándose desde una ventana muy alta del edificio Hampshire House. En su recuerdo. [...] este retablo, habiéndolo ejecutado FRIDA KAHLO.

done regarding the exhibition, and that her paintings were still in customs. After recovering them (with the help of Marcel Duchamp), she took them to the gallery where Breton intended to have the exhibition. After viewing the paintings, the gallery refused to show all but two. Kahlo had done the unthinkable—she had shocked Paris.

"Mexique" was ultimately held at the Colle Gallery (again, thanks to the assistance of Duchamp). On exhibit were Kahlo's paintings and photographs by Manuel Alvarez Bravo. Breton annoyed Kahlo by exhibiting a jumble of various folk objects of varying artistic merit that he had acquired in Mexico—"junk," as she called it. Nevertheless, the objects were no doubt sufficiently exotic to the European sensibility, and Breton's instincts were probably right in presenting them.

While the exhibit was not a financial success (due to the imminent onset of World War II), the Louvre chose to purchase one of Kahlo's works, *The Frame* (c. 1938). *The Frame* is a lively work of mixed media, combining oil paint, metal, and glass into a glorious celebration of color. It can be read as charmingly naive. The purchase by the Louvre was indeed a coup, for *The Frame* was the first work of a Mexican artist ever bought by that institution. Not even "El Maestro" Rivera had achieved that distinction.

However, things were going badly on the personal front. Kahlo's relationship with Rivera was disintegrating, and the two were moving toward divorce. While they were united in their efforts against Nazism and on behalf of Spanish War refugees, they had become personally estranged. Rivera's affairs were a constant irritant to her. In a funk, Kahlo painted *The Two Fridas* (1939), one of her most phenomenal self-portraits, in which she divides herself into separate women sharing the same heart. One depicts the European influences of Kahlo's childhood, the other is the Tehuana Frida inspired by Rivera, the woman of Mexico. The European Frida attempts to close a severed artery by means of a surgical clamp. Though open-ended as usual, the portrait seems to imply that the Frida independent of Rivera holds the means of self-rescue.

TROTSKY'S DEPARTURE

In the midst of this personal agony came various attempts on Trotsky's life. David Siquieros (1896–1974)—ironically, the other leading light of the Mexican muralist movement—sought to machine-gun Trotsky.

Although Mexico was supposed to have provided asylum for Trotsky, it never ceased to be dangerous. Stalin's enmity made itself known the world over, and Mexico's Communist Party was virulently Stalinist. Convinced of his own greatness, Trotsky was somewhat unaware of Rivera's stature in Mexico, the import of which no one would understand until it was too late. In fact, the only person who had stood between Trotsky and death had been Rivera.

Indeed, Rivera, once Trotsky's protector, had had a falling out with him. Trotsky wished to remove Rivera from the Fourth Internationale hierarchy, since he felt that Rivera was acting irresponsibly. While his complaints seemed valid (Rivera was an unreliable bureaucrat), they also seemed like sorry compensation for the trouble Rivera had gone to in shielding him.

Trotsky then made the mistake of appealing to his former lover, not realizing that Kahlo, whatever their differences, always sided with her husband in everything. After all, she willingly had relinquished her own Party membership after Rivera's theatrical resignation. Kahlo's unwillingness to intercede on Trotsky's behalf signaled that he had begun to pall in her eyes as well.

The successful assassination attempt came on August 21, when Ramón Mercader stabbed Trotsky's head with an ice pick. Unfortunately, the assassin was known to Kahlo. Perceiving that knowing Kahlo could gain him entree into Trotsky's life, Mercader had pursued her while she was in Paris, and later in Mexico. As a result, Kahlo was thought to be a prime suspect in whatever conspiracy was present, and both she and Cristina were questioned by the police for twelve hours. Rivera fled to evade any fallout of the fracas.

Being left to take the heat in the Trotsky debacle was only one of Kahlo's resentments against Rivera—actually, a minor one at that. On November 6, 1939, the Riveras were formally divorced.

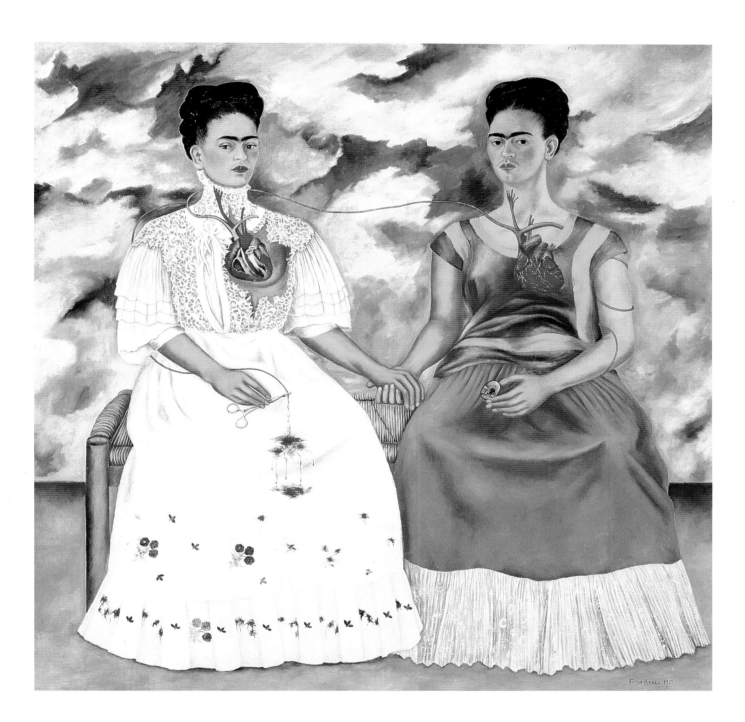

The Two Fridas

Frida Kahlo; *1939; oil on canvas; 67 x 67 in. (170.18 x 170.18 cm). Museo de Arte Moderno, Mexico City.*
In this painting, one of her masterpieces, Kahlo again displays her two sides: her European
upbringing and the "Tehuana woman" Rivera encouraged her to become. The European
Frida attempts to clamp the severed artery that is draining the blood from both of them.

Self-Portrait with Cropped Hair

FRIDA KAHLO; *1940; oil on canvas; 15¾ x 11 in. (40 x 28 cm).*

Gift of Edgar Kaufman, Jr., The Museum of Modern Art, New York.

Rivera loved Kahlo's long hair. Thus, whenever their
relationship became unbearable to her, she would
retaliate by cutting her hair. Here, she is in man's dress,
with her cropped hair surrounding her like an accusation.

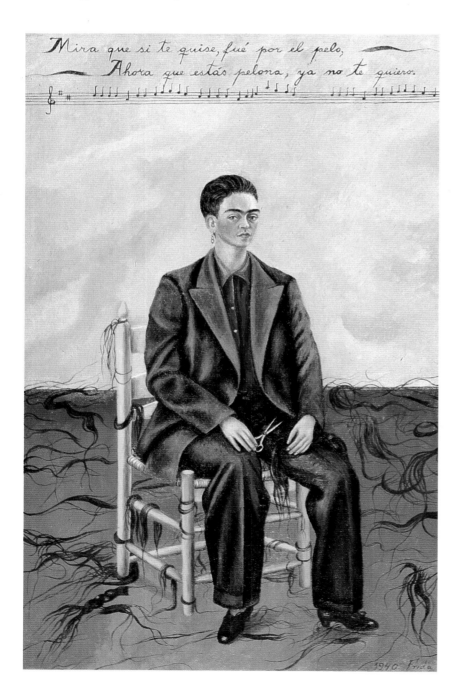

ALONE AND TOGETHER

Partly to keep her mind off her problems, Kahlo
rushed to complete her painting *The Wounded Table*
(1940) in time for the International Surrealism
Exhibition to be held in Mexiço City. The painting
contains two of the *Four Inhabitants of Mexico*; in it,
Kahlo is flanked by a Judas and a skeleton.

The events preceding and following
the divorce inspired several of Kahlo's
most memorable self-portraits, among
them *Self-Portrait with Thorny Necklace*
(1940). This self-portrait, another self-
with-monkey commission, indicated that
life without Rivera was affecting Kahlo's
equilibrium. Her eyelids are heavy, the
cat hostile, and the monkey tugs at her
thorny necklace. The dead bird mirrors
the arc of Kahlo's eyebrows and exagger-
ated mustache.

Outwardly, Kahlo was lighthearted;
she bought herself gold teeth with pink
diamonds as ornaments. But she had
begun to seek as much solace in alcohol
as she had in art. All of this led to a con-
tinuing depression and physical deterio-
ration. Her Mexican specialists were
urging all types of operations, and she
was confused about which actions to
take. Her paintings *The Wounded Table*
and *The Dream*, with their menacing as-
pects, reflected her unease.

Self-Portrait with Cropped Hair (1940)
was another attempt to get back at
Rivera. As in 1935, when Kahlo discov-
ered Rivera's affair with Cristina, she
once again cut off her hair. By doing so,
she wounded Rivera, who loved her long
hair, and distanced herself from her pain
by removing this symbol of femininity.
In *Self-Portrait with Cropped Hair*, she
went a step further by appearing in male
dress. Unlike the earlier portrait, which
affected a dubious gaiety, her cropped
hair surrounds her as a symbol of despair.

Rivera, for all his inappropriate behav-
ior, missed Kahlo but was unsure how to

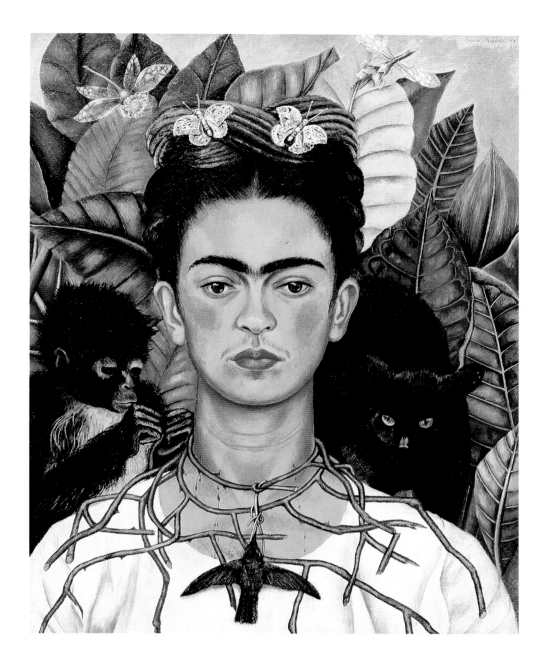

Self-Portrait with Thorny Necklace

FRIDA KAHLO; *1940; oil on canvas; 24½ x 18¼ in. (62.23 x 46.35 cm). Iconography Collection, Harry Ransom Humanities Research Center, University of Texas, Austin.* Life without Rivera affected Kahlo's equilibrium, as can be divined from this portrait. Her eyelids are heavy, the cat hostile, and the monkey tugs at her thorny necklace. The dead bird, a traditional symbol of woe, mirrors the arc of Kahlo's eyebrows and her exaggerated mustache.

effect a reconciliation. He was concerned for her health, enough to suggest that she consult their mutual friend Dr. Leo Eloesser in San Francisco for a professional opinion.

Kahlo arrived in San Francisco in September of 1940 and was diagnosed by Eloesser as suffering from exhaustion and alcoholism. No surgery was necessary at the time, but she was admitted to St. Luke's Hospital for a rest cure. Rivera came to San

Francisco, and Eloesser was able to effect a reconciliation between the two.

The circumstances of the reconciliation were peculiar. Among the most unusual was Kahlo's condition that she and Rivera desist from sexual relations, since she did not wish to share him in this way with all his liaisons, to whom Kahlo had (intellectually, at least) become accustomed. A second condition, unusual for the time, was that Kahlo would support herself by her own

work, and that Rivera would contribute half of her living expenses.

While in San Francisco, Kahlo participated in the International Golden Gate Exhibition. Rivera also participated, painting a mural on Treasure Island. Kahlo and Rivera also traveled to New York to see the "Twenty Centuries of Mexican Art" exhibition, in which *The Two Fridas* was displayed. They then returned to San Francisco, where they were remarried on December 8, 1940.

Kahlo celebrated the reconciliation in her *Self-Portrait with Braid* (1941), in which her hair is reattached to her head in a tight, colorful braid. The portrait intimated that she would strengthen the bonds between herself and Rivera.

In the midst of the Riveras' reconciliation, Guillermo Kahlo died in 1941. The death of her father affected Kahlo deeply, so deeply that it would be ten years before she would paint his portrait.

Kahlo also continued to paint and to exhibit her works. She painted a number of portraits of the family of Eduardo Morillo Safa, a great patron of hers. These included a portrait of *Doña Rosita Morillo* (1941) Morillo's grandmother, whom Kahlo has invested with the presence of a family matriarch.

Kahlo also painted *The Flower Basket* (1941), a remarkably precise still life, for the film actress Paulette Goddard. Perhaps significantly, Goddard appears beside Rivera in his Treasure Island mural.

The Flower Basket

FRIDA KAHLO; *1941; oil on copper; 25¹/₃ in. diameter
(64.26 cm). Mary-Anne Martin Fine Arts, New York.*
This still life, painted for the film actress (and possible
Rivera paramour) Paulette Goddard, demonstrates
the degree and accuracy of Kahlo's craftsmanship.

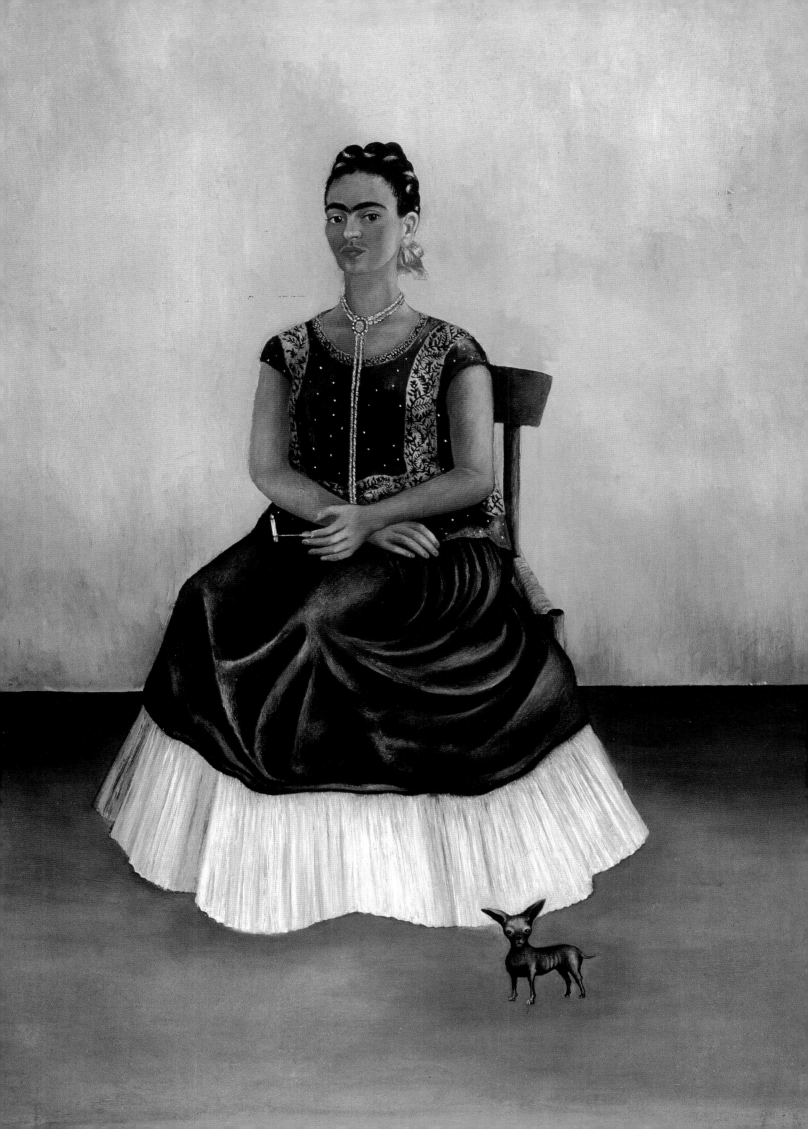

Me and My Doll

FRIDA KAHLO; *1937; oil on metal;*
15¾ x 12¼ in. (38.73 x 31.11 cm).
Private collection.

Kahlo had a multitude of dolls on whom she lavished great affection. Here, she is seated with a European-style doll the size of a human infant. Although her smoking establishes her rebellious nature, another theme of the composition is frustrated motherhood.

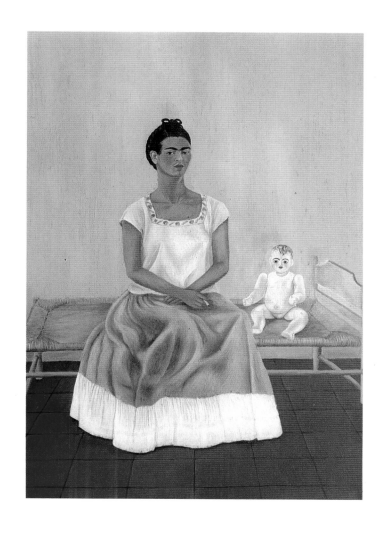

Itzcuintli Dog with Me

1938; oil on canvas; 11 x 8 in. (27.94 x 20.32 cm).
The National Museum of Women in the Arts, Washington, D.C.
A self-possessed, Tehuana-style Kahlo sits smoking in a room, empty but for a clay figure of Mexico's indigenous dog, probably a visual reference to Rivera, whose collection of pre-Columbian artifacts was enormous.

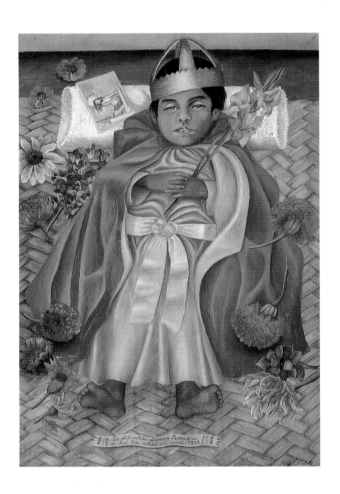

The Deceased Dimas Rosas

FRIDA KAHLO; *1937; oil on masonite;*
18⅞ x 12⅜ in. (48 x 31.43 cm).
Fundacion Dolores Olmedo, Mexico City.
Very few paintings capture the unbearable
sorrow of infant mortality as well as this
"remembrance" portrait. The young Dimas
was the son of one of Rivera's *compadres*;
both Riveras felt the boy had died from
not receiving proper medical attention.

What the Water Gave Me

FRIDA KAHLO; *1938; oil on canvas;*
38 x 30 in. (96.52 x 76.2 cm). Private collection.
This brilliantly surreal work captures the state of musing
while sitting in a bath. Here, Kahlo's mind wanders
through various visions, including her parents' wedding,
her own Tehuana costume, and images of love and death.

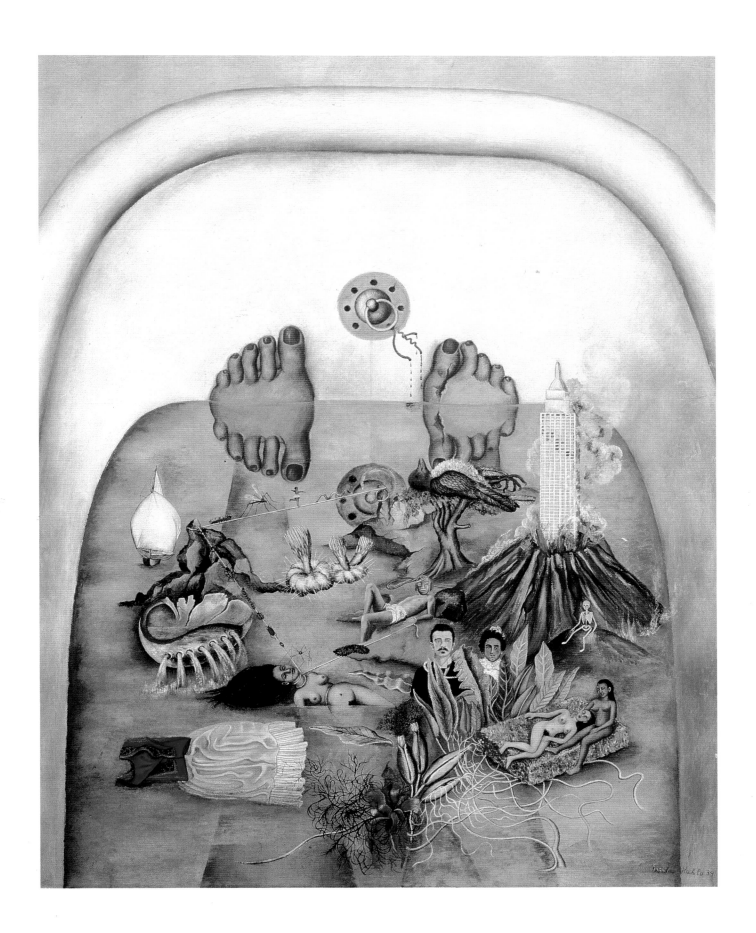

My Nurse and I

FRIDA KAHLO; *1937; oil on metal; 11¾ x 13¾ in.*
(29.84 x 34.92 cm). Fundacion Dolores Olmedo, Mexico City.
Here, the infant Frida is also the adult Frida.
The milk of the nurse, glistening and sweet-
looking, is bursting from her breasts. As
with many Kahlo paintings, this one is imbued
with a disturbing and elusive eroticism.

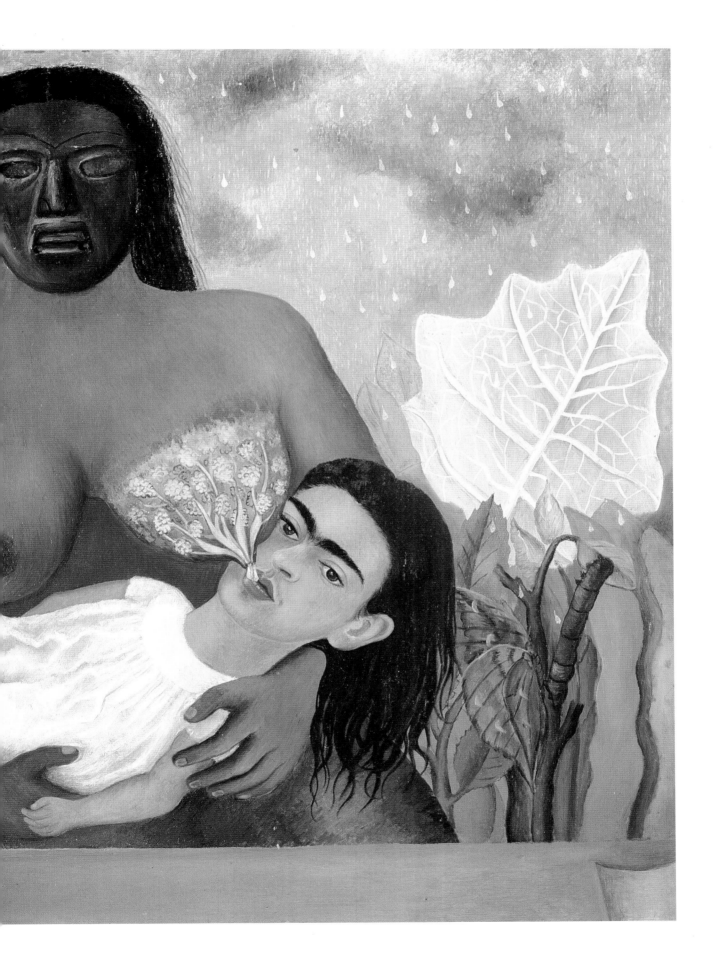

Flat Stamp—
Masked Figure with Headdress

The rigid, coifed figure in this ancient Mexican
flat stamp bears some resemblance to Kahlo's own
self-portraits in both posture and style of dress.

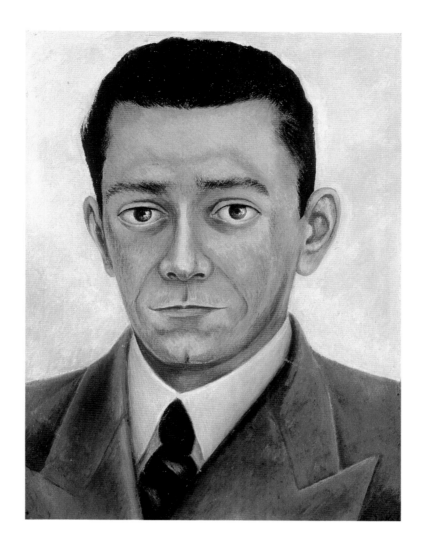

Eduardo Morillo Ing.

FRIDA KAHLO; *1944; oil on canvas; 30½ x 28½ in. (77.47 x 72.39 cm).*

Fundacion Dolores Olmedo, Mexico City.

It was Kahlo's perception combined with the seeming naiveté of her style that
so effectively captured the features of her portrait subjects. This handsome,
somewhat plaintive face stares out at the viewer, engraving itself on the memory.

Kahlo with Monkey

1944; archival photograph.
Corbis-Bettmann.
Kahlo had a fondness for
monkeys, which, perhaps
more than other animals,
resemble children.
She frequently depicted
them in her self-portraits.

Self-Portrait with Monkey

FRIDA KAHLO; *1940; oil on masonite; 21 x 16¾ in. (53.34 x 42.54 cm). Private collection.*
Even more forbidding than *Self-Portrait with Thorny Necklace* is this
work, in which Kahlo's gaze is hostile and the monkey apprehensive.
The red ribbons, one of Kahlo's favorite motifs, threaten to choke her.

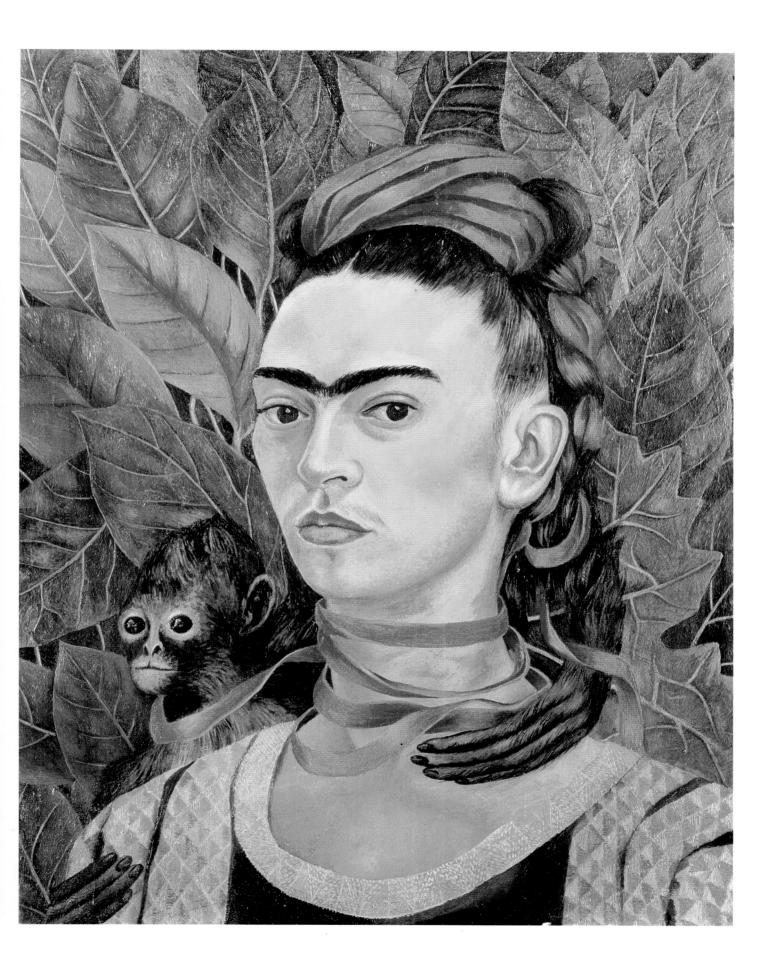

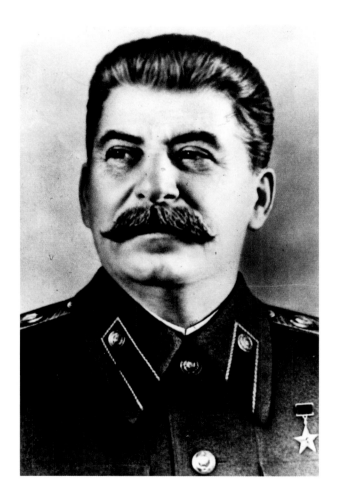

Stalin

n.d.; archival photograph. Corbis-Bettmann.

Josef Stalin, the dictator of Russia and the focus of the
Communist Party, was at first reviled by the Riveras, who
both harbored his enemy Leon Trotsky in their respective
homes in Mexico. Their attitude changed with time.

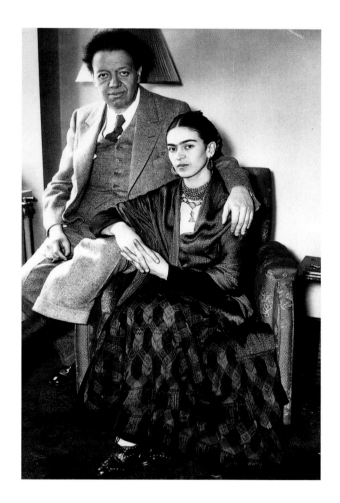

Diego and Frida

1939; archival photograph. UPI/Corbis-Bettmann.

This publicity photo, taken in 1939 when Rivera
denounced the activities of German Nazis and Stalinist
Communists, shows the Riveras as a united front. The truth
was quite different, as the couple was about to divorce.

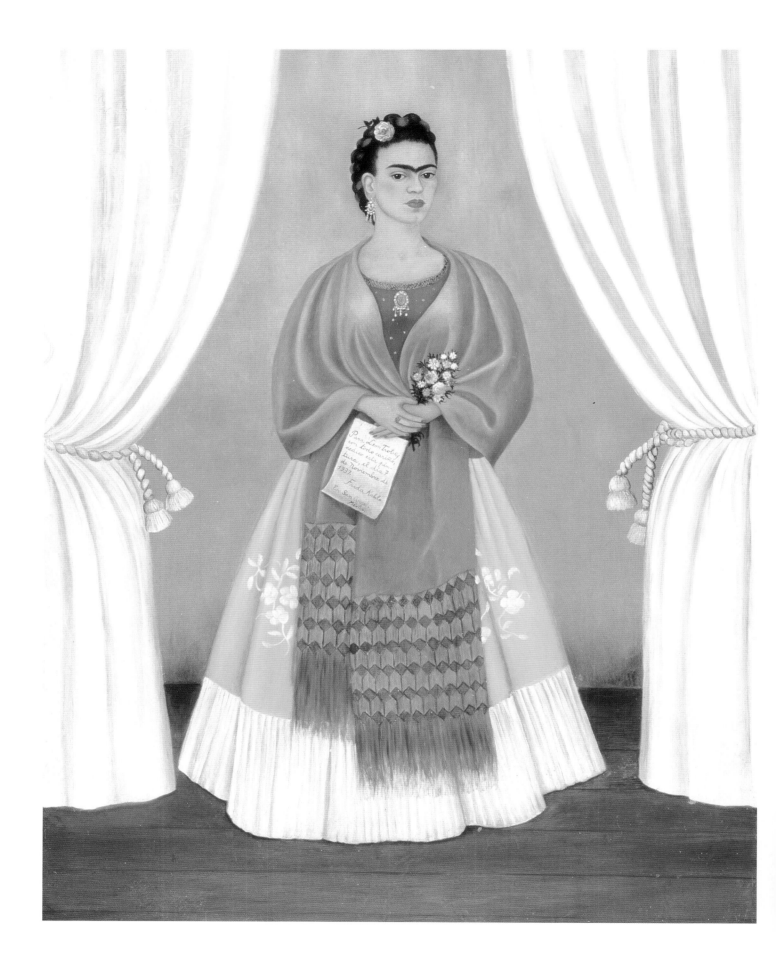

Frida

1939; archival photograph.
UPI/Corbis-Bettmann.
In March of 1939, Kahlo
arrived in New York City
on the *S.S. Normandie,* fresh
from her conquest of Paris.
Yet in the caption to this
news photo, she is still
referred to as "the wife of
the well-known painter."

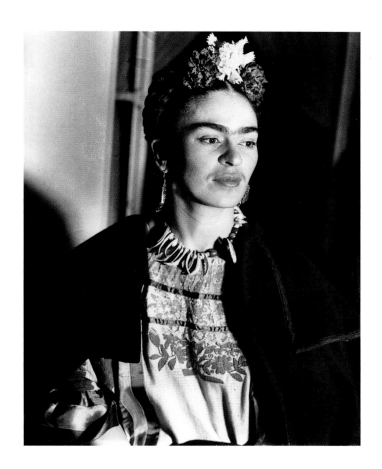

Self-Portrait
(Dedicated to Leon Trotsky)

FRIDA KAHLO; *1937; oil on masonite; 30 x 24 in.*
(76.2 x 61 cm). Gift of the Honorable Clare Boothe Luce,
National Museum of Women in the Arts, Washington, D.C.
Kahlo, dressed in European clothes, is the epitome
of modest feminine comportment. André Breton
discovered this painting while visiting Leon
Trotsky; it led him to declare Kahlo a Surrealist.

Two Nudes in the Jungle

FRIDA KAHLO; *1939;*
oil on sheet metal;
9⅞ x 11⅞ in.
(25.08 x 30.16 cm).
Mary-Anne Martin
Fine Arts, New York.
The subjects of this
painting were first
found floating on a
sponge in *What the*
Water Gave Me; here,
they find themselves
alone (except for a
monkey) in a forest.
The painting, with
its erotic appeal,
alludes to Kahlo's
attraction to women.

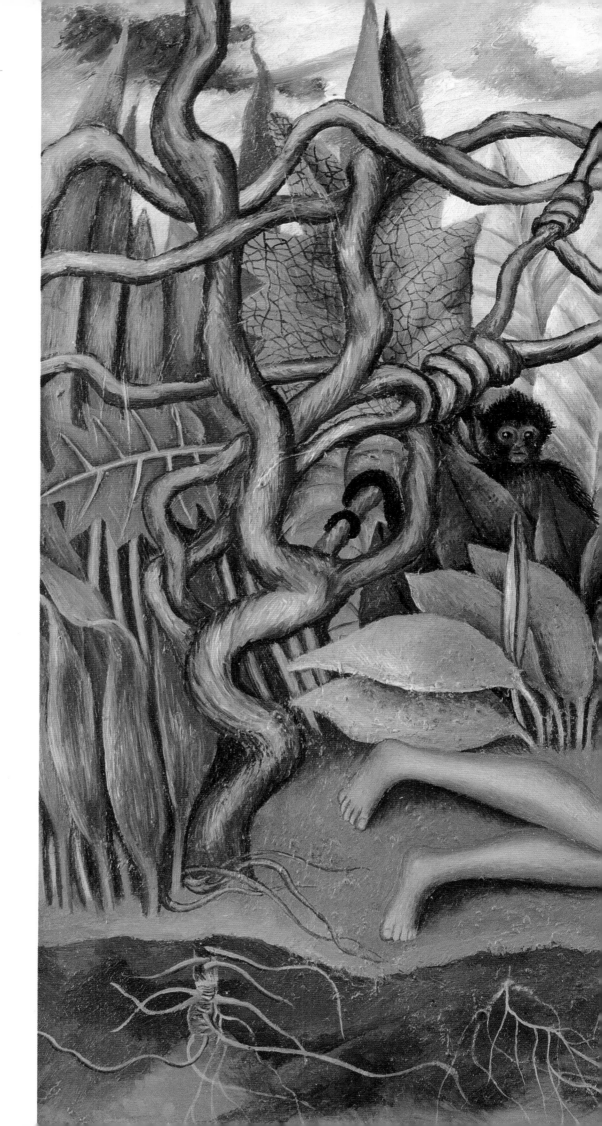

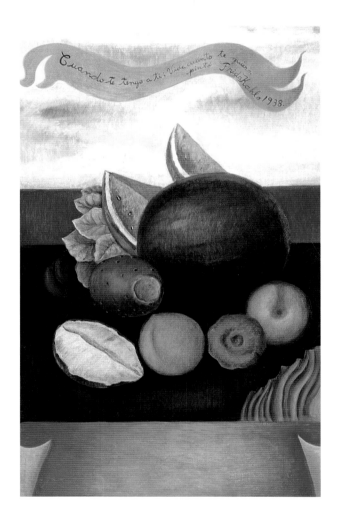

Still Life
"Life, How I Love You"

FRIDA KAHLO; *1938; oil on board; 24 x 14 in. (55.6 x 35.6 cm). Private collection.*

This still life, painted during Kahlo's most artistically productive period, reflects a spirit of unguarded optimism seldom found in her work. The blatant themes of eroticism and physical corruption, which Kahlo frequently explored in her still lifes, are temporarily abandoned for an affirmation of life.

Dona Rosita Morillo

FRIDA KAHLO; *1941; oil on canvas, mounted on masonite; 30½ x 28½ in. (77.47 x 72.39 cm). Fundacion Dolores Olmedo, Mexico City.*

Here is the essence of portraiture: a remarkable likeness that could not be captured simply by photography. Behind the subject is a flowering cactus and beyond that an impenetrable foliage—both of which are standard symbols of life for Kahlo.

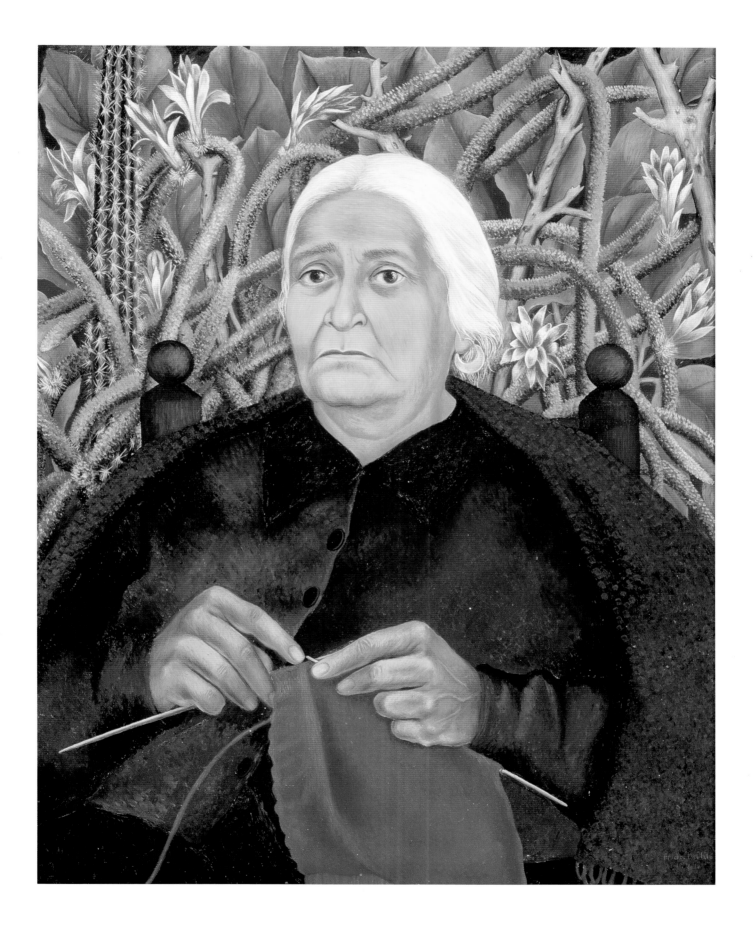

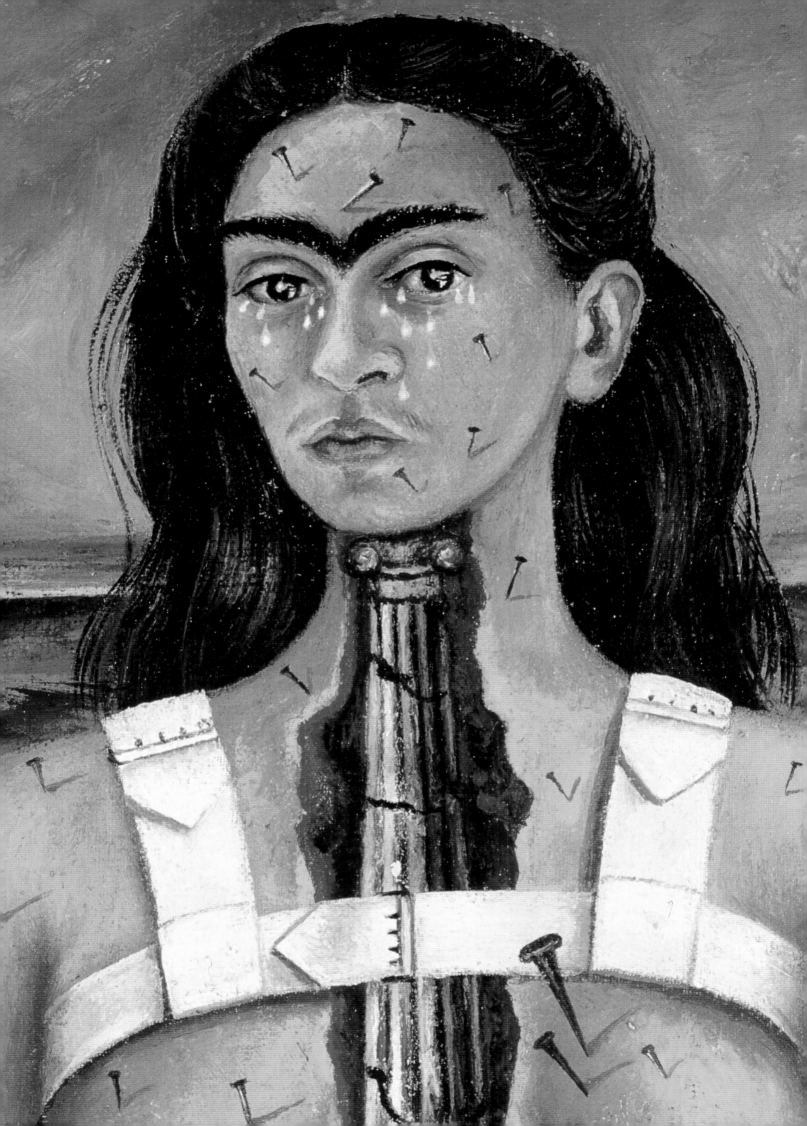

"DEATH DANCES AROUND MY BED" 1942–1954

"Death dances around my bed." That phrase, once used by the young Kahlo to describe her feelings following her streetcar accident, became more prophetic as her life drew near to its close. Kahlo's health would continue to deteriorate, and she would require even more operations just to maintain her hold on life.

FAME AND RECOGNITION

The years following remarriage showed the increasing emergence of Kahlo's fame throughout the world. Her relationship with Rivera continued as it had always been—a series of eruptions regarding his many affairs, secrecy about her own, and mutual admiration for each other's work. Although they had forsworn conjugal relations, Rivera's anxiety over Kahlo's health would also affect their relationship.

In one aspect, however, they were together, and that was in Rivera's ambitious effort to build a monument to his pre-Columbian art collection. The Anahuacalli,

The Broken Column

FRIDA KAHLO; *detail; 1944; oil on masonite.*
Fundacion Dolores Olmedo, Mexico City.
Beneath Kahlo's tear-filled eyes, her split and broken body is literally bound together with straps. Larger nails, placed over her heart, symbolize greater pain, both physical and spiritual.

as it would come to be named, was set upon an arid tract of land in what was called the Pedregal. It was there that Rivera claimed he and Kahlo would set up a farm and grow their own food. He poured whatever money he made into the pyramid-like structure, while Kahlo lobbied the Mexican government for funds, assuring them that the Anahuacalli would be turned over to them as a museum at the time of Rivera's death.

In 1942, Rivera was working on *The Totonac Civilization* mural at the National Palace in Mexico City. This mural, filled with accurate representations of ancient motifs, is like a window into the past.

Kahlo was also busy. In addition to the growing recognition of her name in the United States and Europe, she was also achieving greater status in her native country. Kahlo was one of twenty-five artists who founded the Seminario de Cultura Mexicana, the purpose of which was to promote Mexican culture. She was actively participating in various cultural events, such as the Salon Libre 20 de Noviembre, an open exhibition of paintings.

Demand for Kahlo's work, particularly for her self-portraits with animals, had been increasing. This was good, since as a result of the divorce and remarriage, she had decided to be partly independent of Rivera's money. Not only that, but she was actively helping Rivera with Anahuacalli. She began painting for money in earnest, in part to pay her bills and in part to help Rivera build his dream.

This was also the year that Kahlo began her now famous journal, in which she sketched and wrote down her thoughts until the time of her death. The journal, intensely private in nature, became a treasure trove for the historians and biographers who would examine her life and career.

Kahlo's portraits, such as the likenesses she painted of Natasha Gelman (1943) and Lupita Morillo Safa (1944), were very popular; but even more popular were her self-portraits, particularly the ones that followed the formula of *Fulang-Chang and Me*. Added at this time to the self-with-monkey portraits of previous years were *Self-Portrait with Monkey and Parrot* (1942), *Self-Portrait with Monkeys* (1943), *Self-Portrait with Monkey* (1945), and *Self-Portrait with Small Monkey* (1945). In these, the right combination of art and commerce was attained, for Kahlo could be true to her vision while treating buyers to the exotic, but not the disturbingly bizarre, side of her own nature. The bold woman in Tehuana dress, the exotic foliage, and the engaging animals were arresting enough, and yet could hang on the walls without shocking visitors.

Strangely enough, Kahlo's still lifes, normally a neutral subject for composition, were often judged as unseemly. In *Still Life* (1942) and *The Bride Frightened at Seeing Life Opened* (1943), the bright colors and sharply drawn images seem to undulate with barely concealed erotic energy. *Still Life*, which was commissioned by President Camacho, was turned down by him, probably due to its suggestive images. And, as is usual with Kahlo, the open fruits, revealing and even

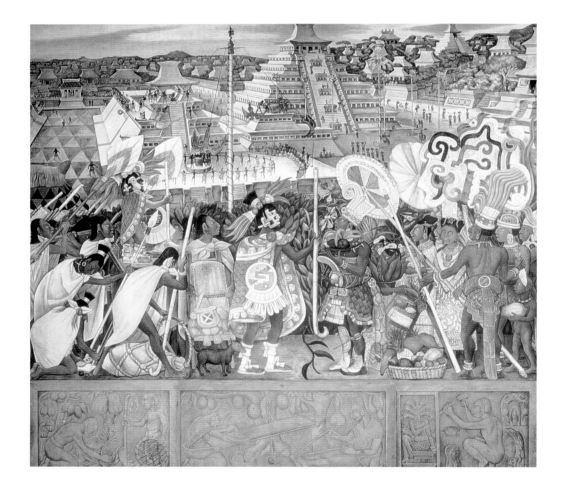

The Totonac Civilization

DIEGO RIVERA; *1942; fresco; 302 x 17¼ ft. (92 x 5.27 m).*
National Palace, Mexico City.
Rivera was an ardent collector of pre-Columbian art.
This mural, filled with accurate representations
of ancient motifs, is a window into the past.

Self-Portrait with Monkey and Parrot

FRIDA KAHLO; *1942; oil on masonite; 21 x 17 in. (53.34 x 43.18 cm).*
Collection of the Fundación Constantini/Courtesy of Sotheby's, New York.
At the time of this work, demand for Kahlo's paintings,
particularly her self-portraits with animals, had been increasing.
This was particularly good, since as a result of the divorce
and remarriage she had decided to be independent of Rivera.

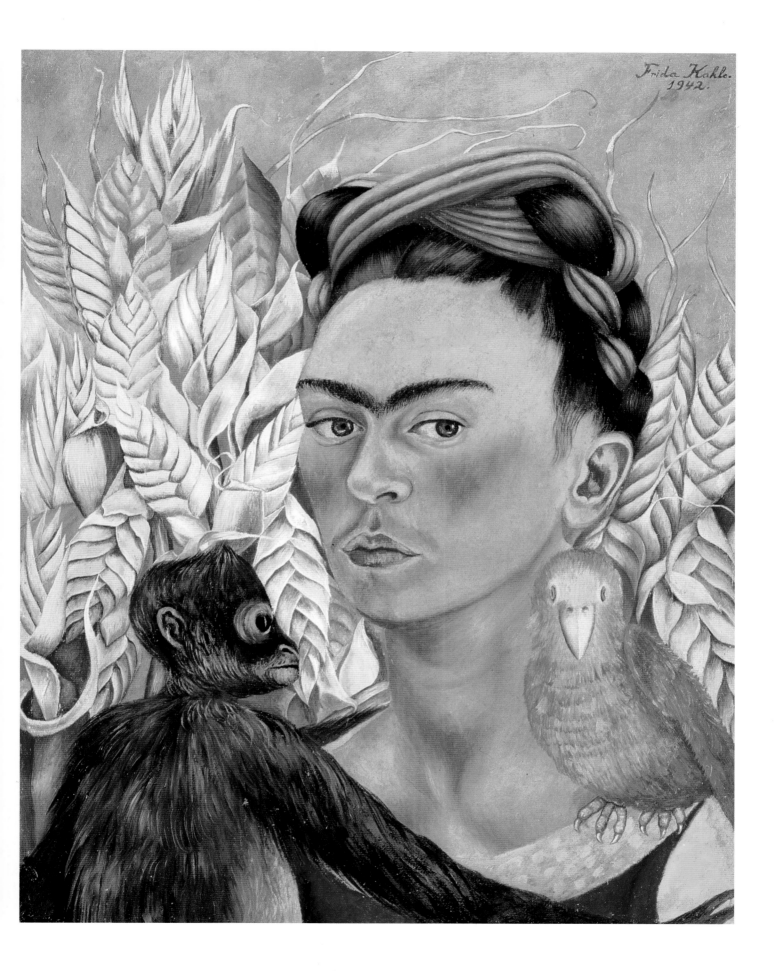

Still Life

FRIDA KAHLO; *detail; 1942;
oil on metal. Frida Kahlo
Museum, Mexico City.*
The melon, which bears
within its own overripe
flesh the seeds for
another generation, is a
metaphor for life itself,
portraying the cycles
of birth, ripening, and
decay which symbolize
the entire earth.

flaunting their interiors, were a metaphor for her own body, which was often distressed with wounds that would not close, which she would offer up to visitors for inspection. And these are nothing compared to *Xochitl* and *Flower of Life*, which are blatantly pornographic.

The international recognition for Kahlo that began in 1938 was increasing. In 1942, her work was included in an exhibition at New York's Museum of Modern Art entitled "Twentieth-Century Portraits." Kahlo was represented by *Self-Portrait with Braid*, her defiant affirmation of continued life with Rivera. This led to Kahlo being included in a New York exhibition of thirty-one women artists at Peggy Guggenheim's Art of this Century Gallery in January of 1943, as well as her inclusion in an exhibit of contemporary Mexican art at the Philadelphia Museum of Fine Art in the same year.

Another of Kahlo's portraits appeared in a group show at Mexico City's Benjamin Franklin Library on January 14. Entitled "A Century of Portraits in Mexico 1930–1842," the show included Kahlo's portrait of Marucha Lavin (1942), a circular work 25 inches (63.3 cm) in diameter.

LOS FRIDOS

Also in 1943, Kahlo was engaged (along with Rivera) as a professor of painting at the Education Ministry's School of Painting and Sculpture, informally known as La Esmeralda. Of the students who enrolled with her, four—Fanny Rabel, Arturio Garcia Bustos, Guillermo Monroy, and Arturo Estrada—would gain fame as Los Fridos. These students continued to study with Kahlo at the Blue House in Coyoacan, as Kahlo's home was called, once pain kept her from going to La Esmeralda.

Kahlo, who had no formal art training, found herself at odds with conventional teaching methods. She treated the students who arrived at her house each day as friends, which was not to say that she did not make them work, that their efforts did not receive criticism, or that she did not plan exercises for them. Rather, her classes were more fluid in their composition; she did not lecture but urged her students to draw what they saw. Often, Rivera would come by and they would implement more conventional teaching methods.

One of Los Fridos' most famous group efforts was the mural painted on the Rosita *pulqueria*. (*Pulquerias* served a fermented drink made out of pulque, a plant

The Great Tenochtitlan

Diego Rivera; *detail; 1944; fresco;*
16 x 32 ft. (4.92 x 9.72 m.). National Palace, Mexico City.
Rivera often included Kahlo in his murals
as a figure of strength. Here, he portrays
her as a tattooed princess, proudly revealing
legs that, in real life, she took care to conceal.

Flower of Life

Frida Kahlo; *1944; oil on masonite; 11¹/₂ x 9 in.*
(29.21 x 22.86 cm). Fundacion Dolores Olmedo, Mexico City.
This "flower of life" is the female reproductive
apparatus, thinly disguised. Flowers are often used
as allegory, but what is uncommon and startling
about this flower is that inside there appears
to be a penis, which ejaculates in a starburst.

that had religious significance dating back to the time of the Maya.) The painting was both an artistic and social success, with much singing of *corridas* and celebrating afterward. A subsequent mural, the Marxist-inspired *Those Who Exploit Us and How They Exploit Us* (1945), met with less success, and was removed from the public laundry at Coyoacan, where it had been painted.

In her self-portraits *Thinking About Death* (1943) and *Self-Portrait as a Tehuana* (1943), Kahlo began to use the forehead as a tableau to visually describe thought. This "window into the mind" would become a favorite motif in her later years. *Roots* (1943), an imaginative work in which Kahlo's reclining body takes root in the stony soil of the Pedregal, is reminiscent of her earlier portrait of Luther Burbank. However, the root—which is part of Kahlo—flows through her ominously empty torso.

In early 1944, Kahlo's painting *The Sun and the Moon* was exhibited in a group show entitled "The Child in Art" at the Benjamin Franklin Library in Mexico City. Although the painting was subsequently lost, its title implies that the picture contained the dual symbolism that Kahlo frequently employed in later years. Duality was something she had earlier expressed more concretely with her "good side–bad side" images of infirmity (as well as in *The Two Fridas*). In later years, duality constituted an elemental force filled with images of lightness and darkness.

Rivera was also working on a mural at the National Palace in Mexico City. In *The Great Tenochtitlan* (1944), Rivera depicted the pre-Columbian world as one of delightful color and vigor. As was his custom, he placed Kahlo in the mural, this time amid the bustle of a market square in the ancient city of Tenochtitlan, lifting her skirts provocatively to reveal slim, tattooed legs.

"THE BROKEN COLUMN" AND "MOSES"

In 1944, Kahlo painted one of her most famous self-portraits, *The Broken Column*, which conveyed her understandable preoccupation with her broken spine. In the painting, Kahlo's spine is an ancient, deteriorating column, appearing through a fissure in her chest. Kahlo is nude from the waist up, save for the straps of a corset that holds her body together; she is totally open and revealed to the spectator. Tears in an impassive face are the only indications of pain brought on by the broken spine and the nails driven into flesh.

The Broken Column is one of the paintings (along with *What the Water Gave Me*) that have attached Kahlo's name to the Surrealist movement. The painting is both definable and mysterious at the same time. First, the column itself is classical Greek in design, rather Mayan. Kahlo may have been alluding to European technology as the reason for her dissolution, but it may also have been that she wanted her audience to immediately grasp her intention, and so she used, this "cliché," as it were, which happened to be of European origin.

Of all Kahlo's paintings, however, it was *Moses* (1945) that brought her recognition in Mexico. Based on a work of Freud's called *Moses and Monotheism*, the painting—which, at almost 30 inches across and 24 inches high (76.2 x 60.9 cm), is among Kahlo's largest—bears some resemblance to Rivera's murals. In the middle, little Moses, armed with the all-seeing third eye with which Kahlo would so often endow Rivera, floats along the Nile, while images of religion, Communism, and biological creation surround him. *Moses* was a complex work for which Kahlo received the National Prize of Arts and Sciences from the Education Ministry in 1946. A purse of five thousand pesos accompanied the honor.

The Broken Column

FRIDA KAHLO; *1944; oil on masonite; 15¼ x 12¼ in. (38.73 x 31.11 cm). Fundacion Dolores Olmedo, Mexico City.*
In one of Kahlo's most famous works, she is totally open and revealed to the spectator. Her spine, broken in real life, is portrayed as an ancient, decrepit column, and the pain that wracks her as little nails.

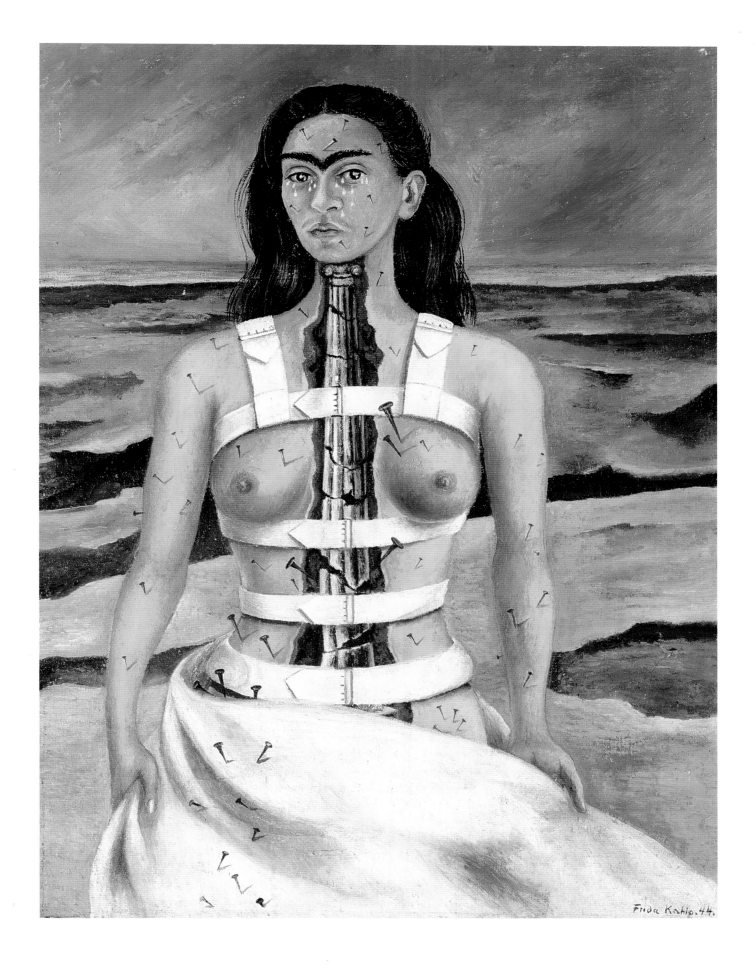

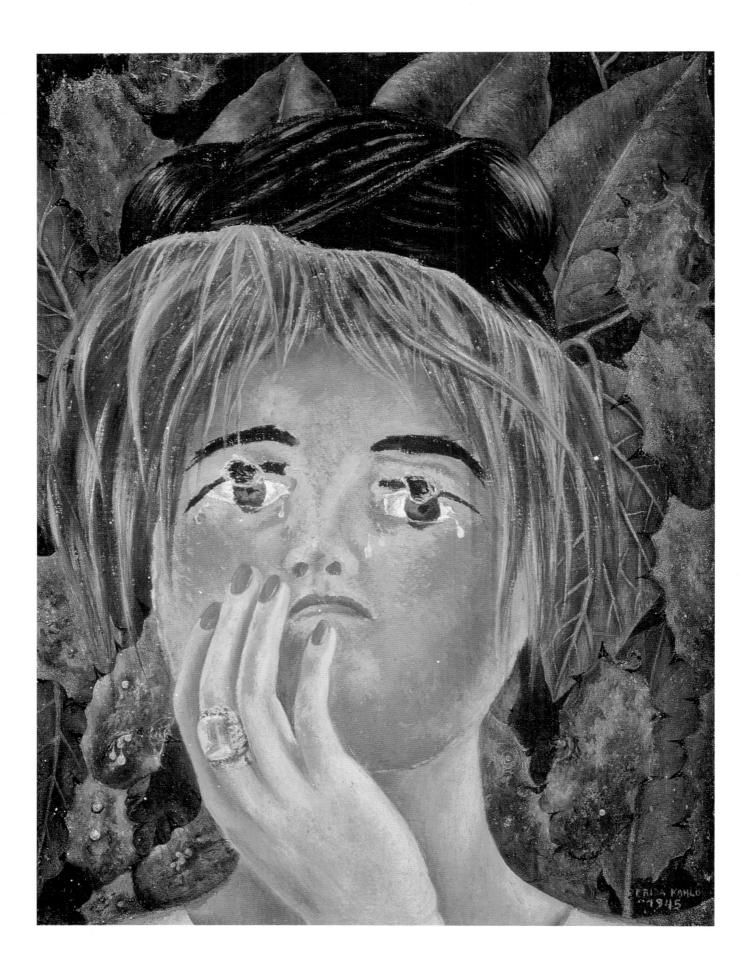

DECLINING HEALTH

Kahlo's health continued to deteriorate. In 1945, she was briefly in the hospital, where she was able to eat only strained food. She painted *Without Hope* (1945), a Brueghelian send-up of her own condition. Also from this time is *The Mask of Madness* (1945), the forlorn at-titude of which is ascribed to yet more anguish over Rivera's repeated infidelities.

In June of 1946, Kahlo traveled to New York City with her sister Cristina to undergo a bone graft oper-ation at the Hospital for Special Surgery. Four of her vertebrae were fused together and a metal rod was in-

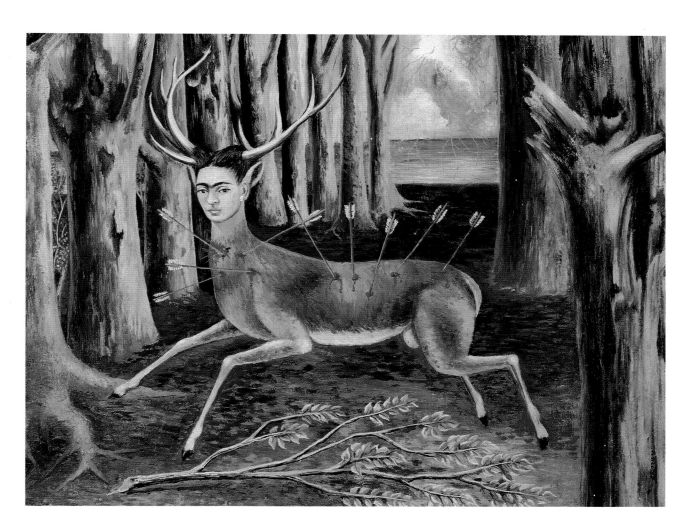

The Mask of Madness

FRIDA KAHLO; *1945; oil on masonite; 15¾ x 11¾ in. (40.13 x 30 cm). Fundacion Dolores Olmedo, Mexico City.*

The bizarre composition and queasy colors in this painting convey a great deal of unease. Kahlo's figures, while often shocking, are characterized by stoic expressions. Here, it is as if the mask is allowing Kahlo to freely express enormous distress.

The Little Deer

FRIDA KAHLO; *1946; oil on masonite; 8⅞ x 11⅞ in. (22.5 x 30.16 cm). Private collection.*

One of Kahlo's most startling portraits, *The Little Deer* evokes alarm by Kahlo's identification with the maimed animal. As usual, Kahlo's expression is stoic, and she looks directly at the viewer.

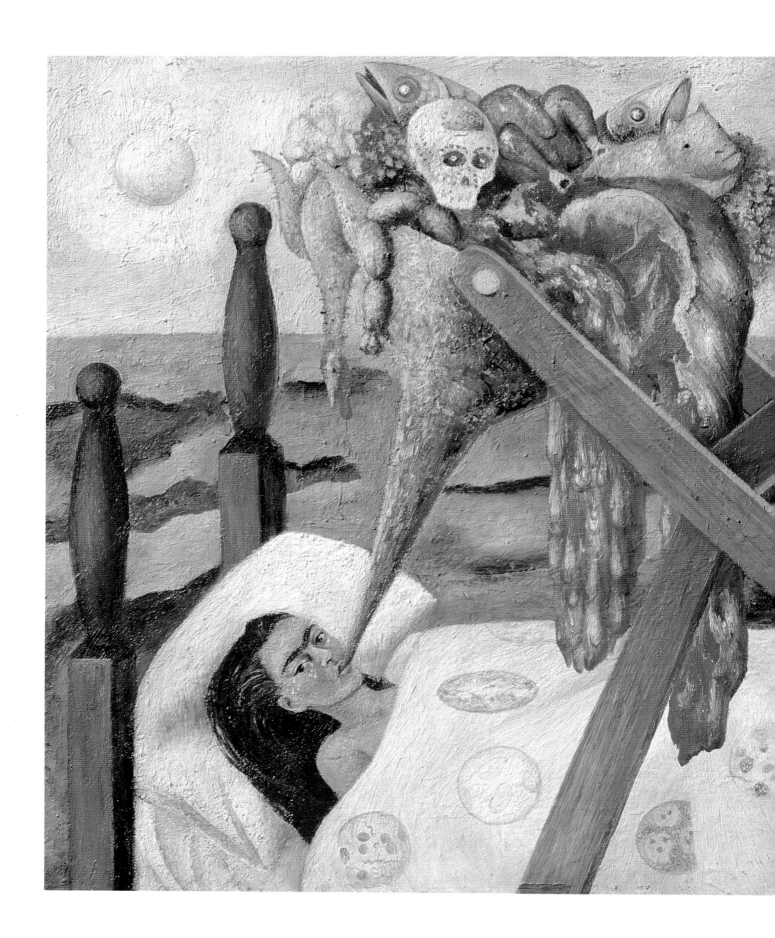

serted to strengthen her spine. Cristina, who held her hand during the operation, later recalled that the pain was so agonizing that Kahlo had to be given massive doses of morphine. It was later thought that, although her physician, Dr. Philip Wilson, was a specialist in operations of this nature, the wrong vertebrae may have been fused. It was also assumed that Kahlo compounded the seriousness of her condition by ignoring doctors' orders and trying to do too much too soon.

Whatever the reason, the operation was for Kahlo the beginning of her physical decline. She was in such great pain that she frequently relied not only on alcohol but on strong painkillers such as Demerol, which she acquired by means both legal and illegal. Upon her return to Mexico, it became necessary for her to spend more and more time in bed.

However, she managed to rally her spirits, as represented by *Tree of Hope, Stay Strong* (1946), in which the Tehuana Frida stands guard over a reclining figure who is also Frida, and who has perhaps become the victim of Western medicine. Dividing them are lightness and darkness, motifs that Kahlo would use increasingly to describe her world. While *Self-Portrait with Loose Hair* (1947) shows the Kahlo of old, the struggle is also present there: Kahlo's face is worn, and her eyes weary.

Kahlo painted another remarkable self-portrait, *The Little Deer* (1946), at this time, in which her head appears on a deer's body. The deer is pierced and bleeding from many arrows. Again, the message is hurt, mortal hurt, perhaps betrayal.

Without Hope

Frida Kahlo; *1945; oil on canvas mounted on masonite; 11 x 14¼ in. (28 x 36.19 cm). Fundacion Dolores Olmedo, Mexico City.* Kahlo gives vent to her frustration over her progressive physical deterioration in this painting. As in *Henry Ford Hospital*, she is once again bedridden and isolated on a desolate plain.

EMBRACING THE UNIVERSE

In 1947, one of Kahlo's self-portraits, probably *Self-Portrait as a Tehuana*, appeared in an exhibition of Mexican artists from the eighteenth to the twentieth centuries sponsored by the National Institute of Fine Arts. And in 1949, Kahlo produced *Diego and I*, in which Rivera appears as a "thought," as well as the ambitious *The Love Embrace of the Universe the Earth (Mexico), Diego, Me and Señor Xolotl*. At the time, Kahlo was worried, since, through her own extreme illness, she was losing her place as Rivera's caretaker. Therefore, she expressed her tender love for Rivera in this painting. To her, he is a child to be cradled in her arms; but since he is also great, he has a third eye that symbolizes his wisdom. The two Riveras are surrounded by light and darkness—as well as by loving domesticity, represented by one of Kahlo's dogs, Señor Xolotl.

The painting was displayed that year as part of the inaugural exhibition of the Salon de la Plastica Mexicana in 1949. As in *Tree of Hope*, images of light and darkness divide the painting. For as she grew sicker, Kahlo's world was dividing into lightness and dark. The light was her love for Rivera, reciprocated by him; friends, children, and animals; the joy of painting. The darkness was Rivera's infidelities and the loneliness caused by his neglect; it was pain and the driving away of pain by drugs and alcohol; the inability to paint while the pain lasted.

As people who are drawing close to death often turn to religion, so Kahlo returned to her core belief, which was Communism.

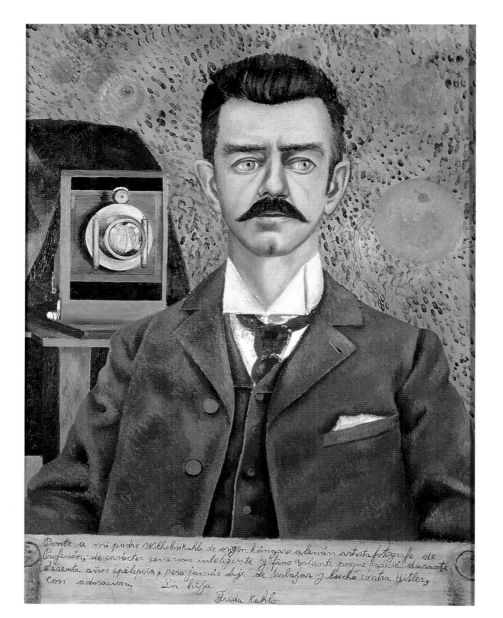

Portrait of Don Guillermo Kahlo

FRIDA KAHLO; *1951;*
oil on masonite; 23³/4 x 18¹/3 in.
(60.45 x 46.48 cm). Private collection.
This portrait of Kahlo's father (who had died ten years earlier) reveals the tenderness with which she regarded him. It took her a long time to come to terms with his death.

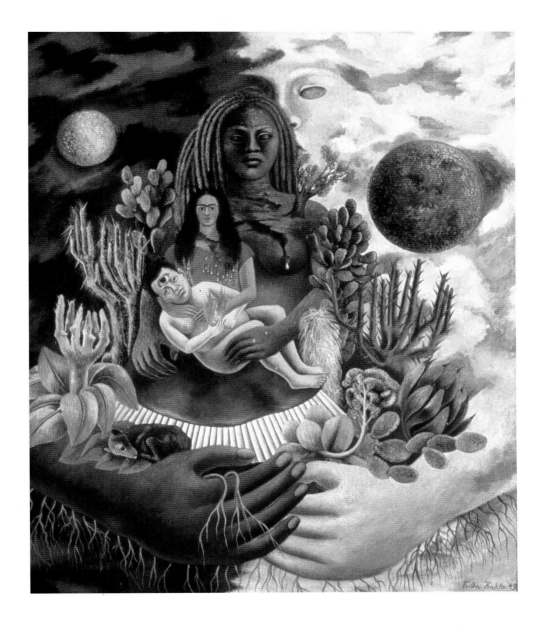

The Love
Embrace of
the Universe,
the Earth
(Mexico),
Diego, Me and
Señor Xolotl

FRIDA KAHLO; *1949;*
oil on canvas; 27½ x 23⅞ in.
(69.85 x 60.64 cm).
Private collection.
At a time when Kahlo,
through illness, was
losing her grasp on the
world around her, she
seemed to find it again
in this gentle painting.
In later paintings like
these, Kahlo explores
symbols of life and death,
such as light and darkness.

Kahlo rejoined the Communist Party in 1952, re-canting the influences of her former lover Trotsky in favor of Stalin. The personal consolation she drew from the Party is represented in later works such as *Marxism Will Give Health to the Sick* (1954), that was among her last works. (She also left behind an unfinished portrait of Stalin.) For the most part, however, Kahlo worried that the lifelong introspection which had been her subject matter had not completely represented her political beliefs. To this end, she began placing symbols in the still lifes that were increasingly her subject matter, even painting the hammer and sickle on her plaster corsets when, in 1950, she was forced to return to Mexico City's ABC Hospital for another bone graft and a year's recuperation.

In 1951, Kahlo painted *Self-Portrait with the Portrait of Doctor Farill* (1951), in which she appears in a wheelchair next to the portrait of a physician to whom she had become close. A huge heart covers her painter's palette, bespeaking her love for the subject. Farill shared an infirmity with Kahlo, as he had had a foot partially amputated; for this reason, he did not perform such operations. In addition, Kahlo painted two paintings dealing with her family: *My Family* (c. 1950–51) and *Portrait of Don Guillermo Kahlo*, her father, ten years after his death. It is a tender portrait that reveals the love with which she thought of him. That she sensed her own life drawing to a close probably helped her come to terms with his death.

TRIUMPH AND TRAGEDY

In April of 1953, Kahlo also had a delightful experience: a one-woman show in Mexico City, given to her by her friend Dolores (Lola) Alvarez Bravo at her Galleria de Arte Contemporaneo. It was an exciting event at which Kahlo, very ill, made a dramatic entrance, escorted by police cars blasting their sirens and carried into the gallery upon her bed. The scope of her work was extremely impressive, and she received many compliments from her more famous husband.

Kahlo delighted in the excitement caused by the show, and for a short while rallied. Unfortunately, she had been ill for too long a time to recover fully. Two months later, she had to return to the hospital.

Kahlo was very ill. By 1953, not only was she completely reliant on painkillers to ease her suffering, but she was told that it would had now become necessary to remove her right leg. This was a shock. There were two major reasons for Kahlo to be sentimental about her right leg: It was the same limb her father had lovingly helped her strengthen after childhood polio had atrophied its muscles, and it was the same limb she had stubbornly held on to after the streetcar accident. In spite of its having caused her pain nearly all her life, she had labored to retain it. During the years it had been slowly turning gangrenous, and she had had to relinquish it toe by toe. Rivera knew how much it meant to her, and tearfully predicted, "This is going to kill her."

After much soul-searching, she gave her consent to have the leg amputated by her friend Dr. Guillermo de Velasco y Polo; but the shock of losing something she had held onto for so long, however futile the effort, seemed to further loosen her ties to life.

Although she had been fitted with, and had mastered the use of, a wooden leg, Kahlo was still worn down from continuous illness. During the last year of her life she spent much time at the ABC Hospital.

In her pain, however, she continued to cling to her political convictions. On July 2, 1954, just out of the hospital, Kahlo attended a protest against American involvement in Guatemala. Rivera pushed her wheelchair, while Kahlo held a sign on which a peace dove was painted. By July 13, Kahlo was dead of a pulmonary embolism.

THREE INSTANCES OF LIFE

In her biography of Frida Kahlo, Hayden Herrera lists three separate occasions when Kahlo's corpse startled her mourners by giving signs of life. First, Olga Campos, a friend, leaned down to kiss Kahlo farewell, and screamed when she saw Kahlo's skin react with goosebumps. Second, Rivera called in the doctor, agitatedly claiming that, since he had seen Kahlo's body hair stand on end, she could not be dead. He was not convinced until an artery was cut open to prove the cessation of blood flow.

The third and most macabre instance occurred as Kahlo was about to be cremated. As mourners, swaying and singing the Internationale, watched Kahlo's body roll into the crematory oven, a blast of heat blew her corpse into a sitting position. People screamed as they saw Kahlo facing them. Then, as her hair caught fire and flared up, she returned to her prone position. To those who loved and knew her best it must have seemed as if her spirit—which had withstood so many agonies—was having difficulty relinquishing life.

Frida Kahlo was mourned as a national treasure. Four years after her death, the Blue House at Coyoacan was opened as a museum to her memory. It may be visited today.

While Kahlo's late paintings lacked the precision of her earlier work, they were still striking expressions of the woman herself. Among her last pictures was the still life *Viva la vida* (1954), in which she has painted, as if carved, the title of the painting. Another, *Self-Portrait with Ixcuintle Dog and Sun* (1953–54), shows Kahlo once again bringing together the elements that had given her happiness: Diego, a beloved pet; herself, as a young woman; and the land of Mexico. For once, the sun is shining against a clear blue sky.

Self-Portrait with Ixcuintle Dog and Sun

FRIDA KAHLO; *1953–54; oil on masonite. Private collection.*
While Kahlo's illness made her less sure of her brushstrokes, the visionary aspects of her painting remained intact. In later years, she began to decorate her forehead with thought symbols.

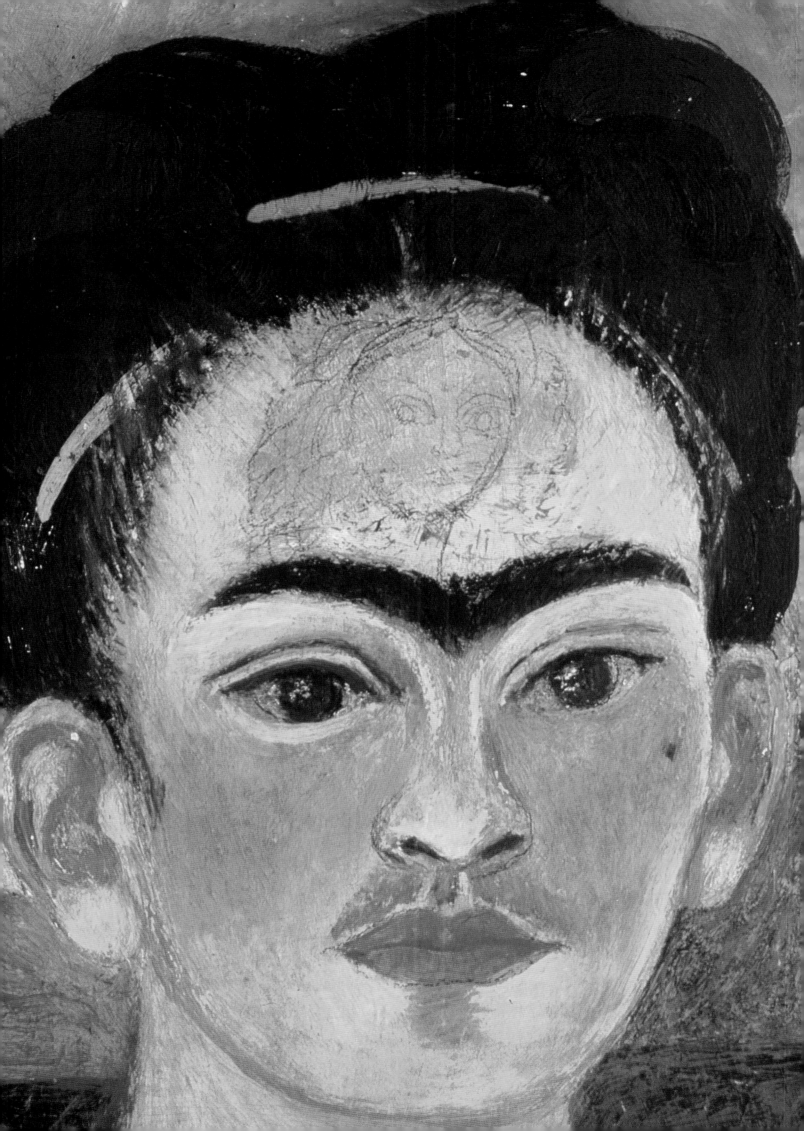

Kahlo

1944; archival photograph.
Corbis-Bettmann.
In the 1940s, Kahlo was
at the height of her fame.
With several shows
throughout the United
States and Europe, she
had acquired her own
patrons and followers.

Still Life

FRIDA KAHLO; *1942; oil on metal; 24⅞ in.*
(63 cm) diameter. Frida Kahlo Museum, Mexico City.
Kahlo's "still lifes" were seldom still. This
painting, with its bright colors and sharp detail,
seems to undulate with energy. As usual, many of
the objects have been opened to reveal their insides.

Flat Stamp of Man with Parrot

Pre-Columbian.

In this antique emblem from Oaxaca, a man in a headdress is balancing a parrot on his arm. Parrots had been domesticated for centuries, and thus were, for Kahlo, a tie to Mexico's past.

Still Life with Parrot

FRIDA KAHLO; *1951; oil on canvas; 10 x 11 in.*
(25.4 x 28 cm). Iconography Collection Harry Ransom
Humanities Research Center, University of Texas, Austin.
A parrot is both mascot and predator in this richly
colored still life filled with ripening and decaying
fruits, icons of sexuality, fertility, and dissolution.

Ceramics

The motifs of ancient Mexico
survive today in part because
of tourism and visitor interest
in Mexico's many archaeo-
logical sites; and partly because
they have been glorified by
the Mexican intelligentsia,
such as Rivera and Kahlo.
Here, a merchant displays
traditional crafts near Tulum.

The Rain God Tlaloc Incensario

Pre-Columbian, c. A.D. 400–700; pottery; provincial
Teotihuacan, Guatemala; Jacksonville Art Museum, Florida.
A figure such as this might have been part of Rivera's
Anahuacalli Museum. The arrangement of decorative
motifs as displayed here can be seen in native folk art.
It was also popularized by Kahlo in her paintings.

The Hammock

DIEGO RIVERA; *1956; oil on tempera. Fundacion Dolores Olmedo, Mexico City.*

In later years, Rivera would revert to the impressionism of his youth. This painting, typical of Rivera's
later work, displays both his appreciation of lovely young women and the influence of his years in Europe.

Rivera

1944; archival photograph. Corbis-Bettmann.

Rivera was as popular as ever in the 1940s,
particularly with women. It was at this time that he
and Kahlo were building the Anahuacalli Museum
to house Rivera's collection of pre-Columbian art.

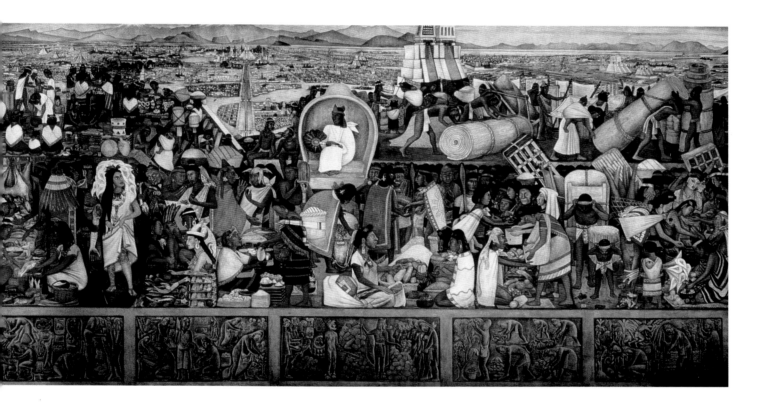

The Great Tenochtitlan

DIEGO RIVERA; *1944; fresco. National Palace, Mexico City.*
Rivera's masterful artistry could revive a civilization that had been dead for centuries. Here, he portrays the bustling market-square of Tlatelolco in the ancient city of Tenochtitlan.

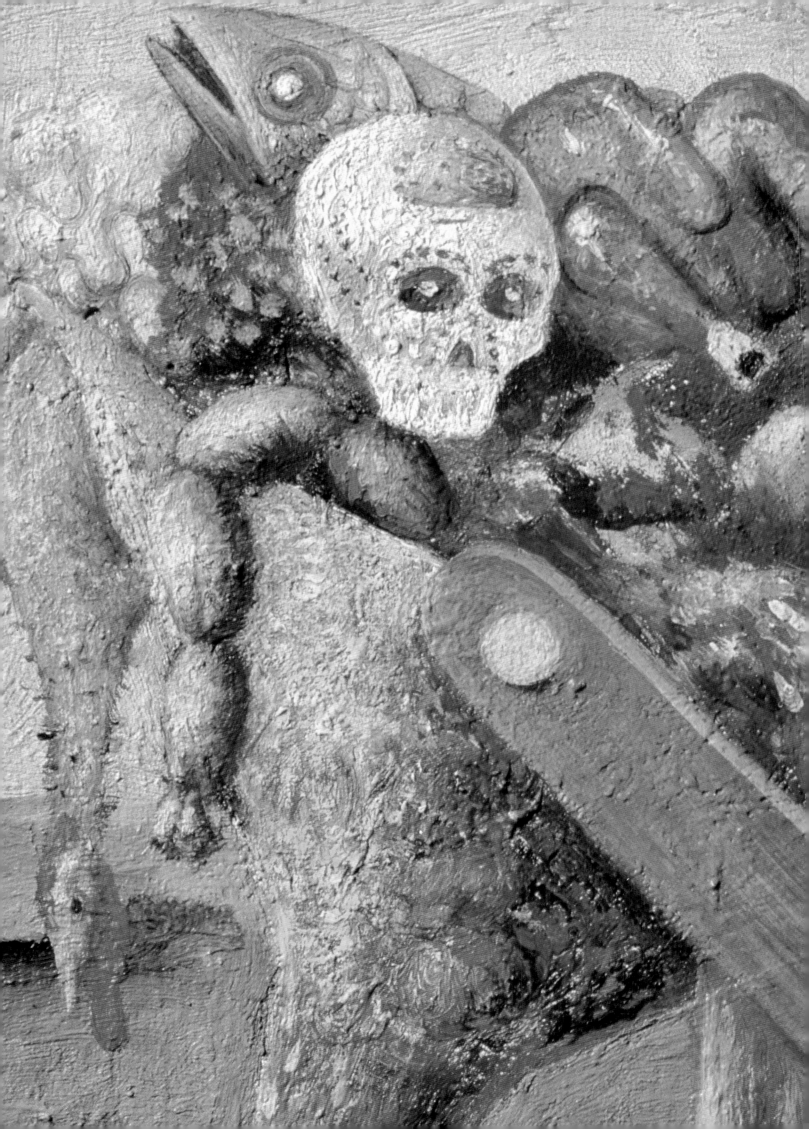

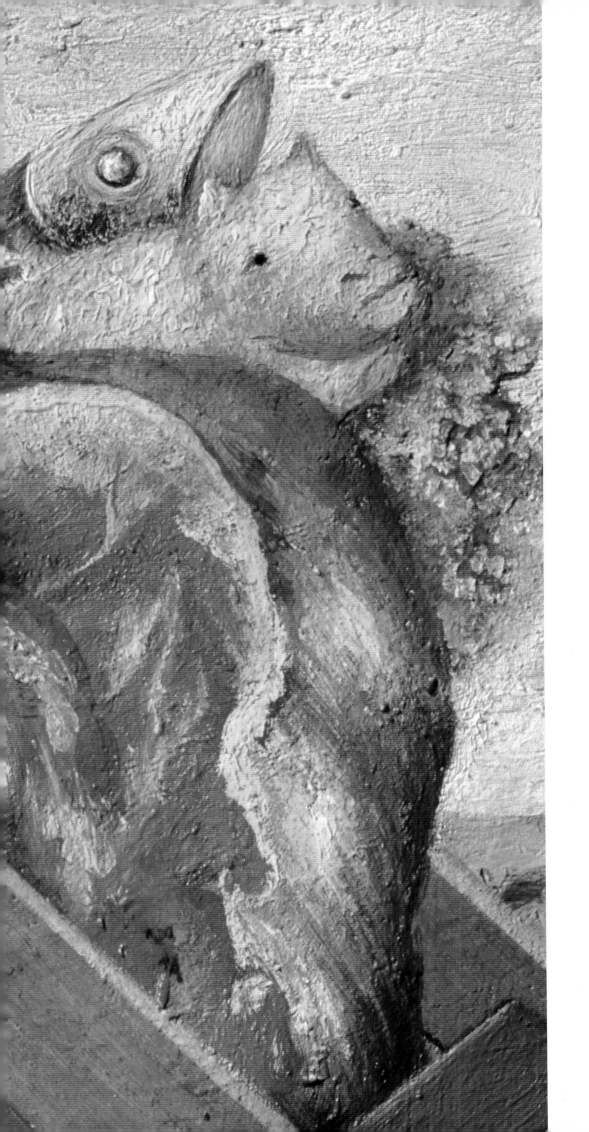

Without Hope

Frida Kahlo; *detail; 1945; oil on canvas mounted on masonite. Fundacion Dolores Olmedo, Mexico City.*

A strange and ominous gathering of objects—fish, a pig and a chicken, a skull displaced from the Day of the Dead, and other, more amorphous matter— bursts forth from a weeping Kahlo, who is trapped in bed within a burning and malevolent landscape.

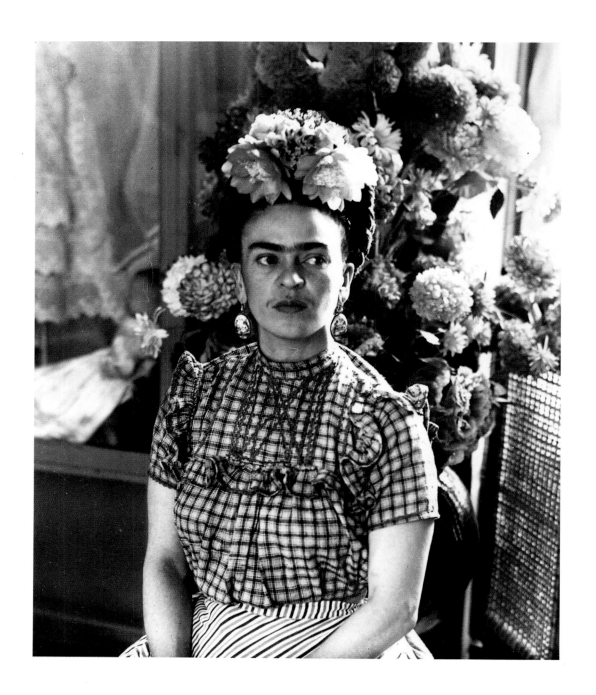

Kahlo

1944; archival photograph. Corbis-Bettmann.

People often remarked how Kahlo would present
herself as a work of art. Here, she sits with her hair
wrapped in intricate braids, topped with flowers.

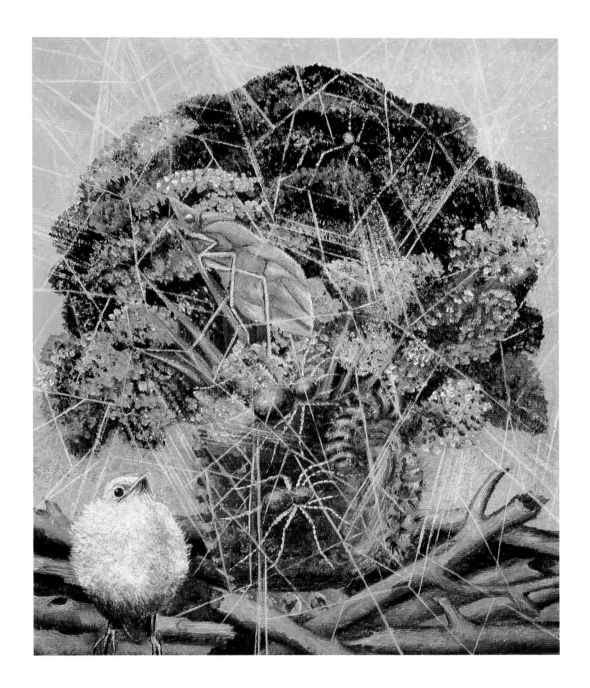

The Chick

FRIDA KAHLO; *1945; oil on masonite; 11 x 8½ in. (28 x 21.84 cm). Fundacion Dolores Olmedo, Mexico City.*
Kahlo has depicted a symbol of innocence and fragility against a lush
background that carries, with its many insects, an undercurrent of menace
and decay—particularly the spider's webs, which fill the picture.

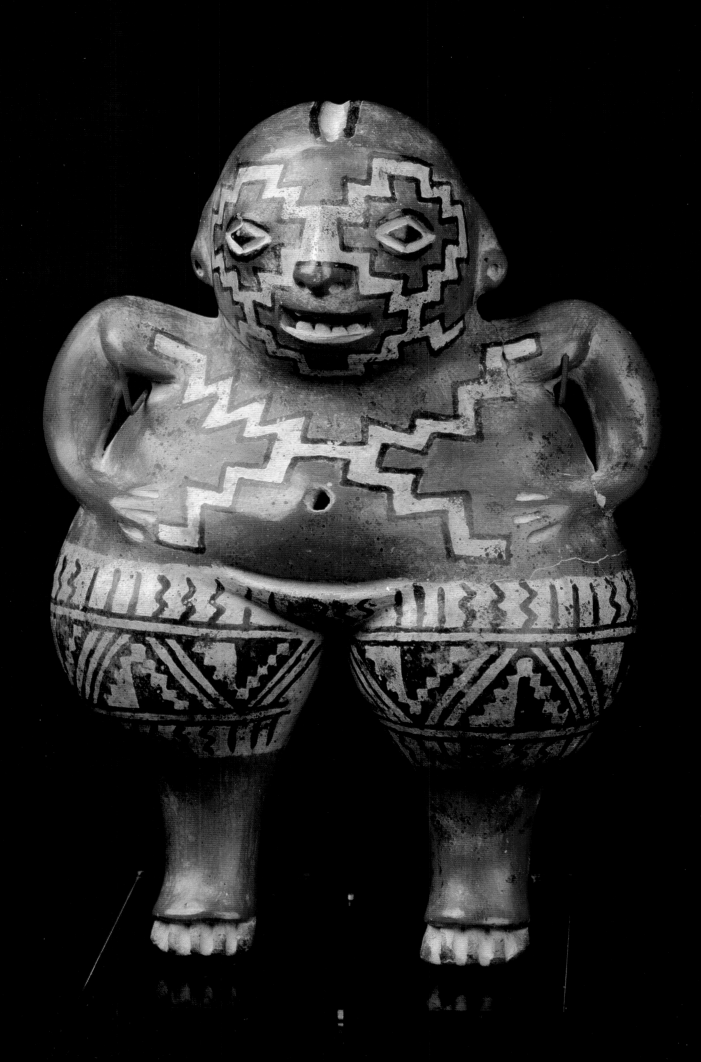

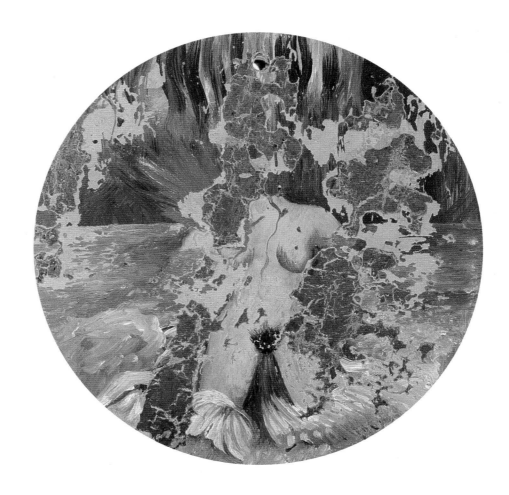

The Circle

FRIDA KAHLO; *c. 1951; oil on sheet metal; 6 in. diameter (15 cm). Fundacion Dolores Olmedo, Mexico City.*
This painting is an interesting abstract in which the female figure (Kahlo) appears as a palimpsest in a field of corrosion. According to Kahlo's biographer Hayden Herrera, it is another expression of her physical deterioration.

Fertility Figure

Pre-Columbian, c. 800 B.C.–A.D. 200; pottery; Chipicuaro, Mexico. Jacksonville Art Museum, Florida.
Rivera was a connoisseur of pre-Columbian artifacts. In his mural *The Great Tenochtitlan* he applies motifs similar to this figure's on Kahlo's legs.

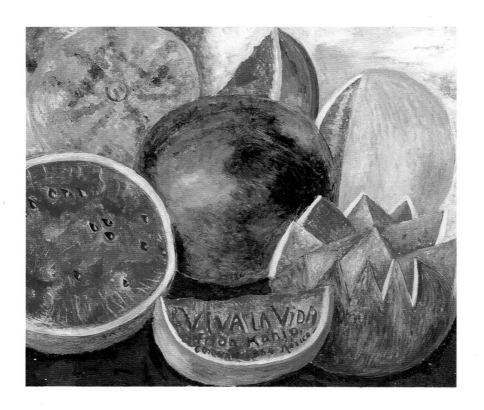

Viva la Vida

FRIDA KAHLO; *1954; oil on masonite;*
23⅓ x 20 in. (59.53 x 50.8 cm). Private collection.
One of Kahlo's last paintings, this is
less an artwork than an expression of her
indomitable will. Kahlo died in this year,
mourned by her beloved husband and
the entire country as a national treasure.

Self-Portrait with Ixcuintle Dog and Sun

FRIDA KAHLO; *1953–54; oil on masonite;*
23 x 15¾ in. (58.42 x 40 cm). Private collection.
Here, the self Kahlo projects is a
memory: a young woman in Tehuana
dress with stone beads. Her beloved
Rivera and an *ixcuintle* dog are with her.

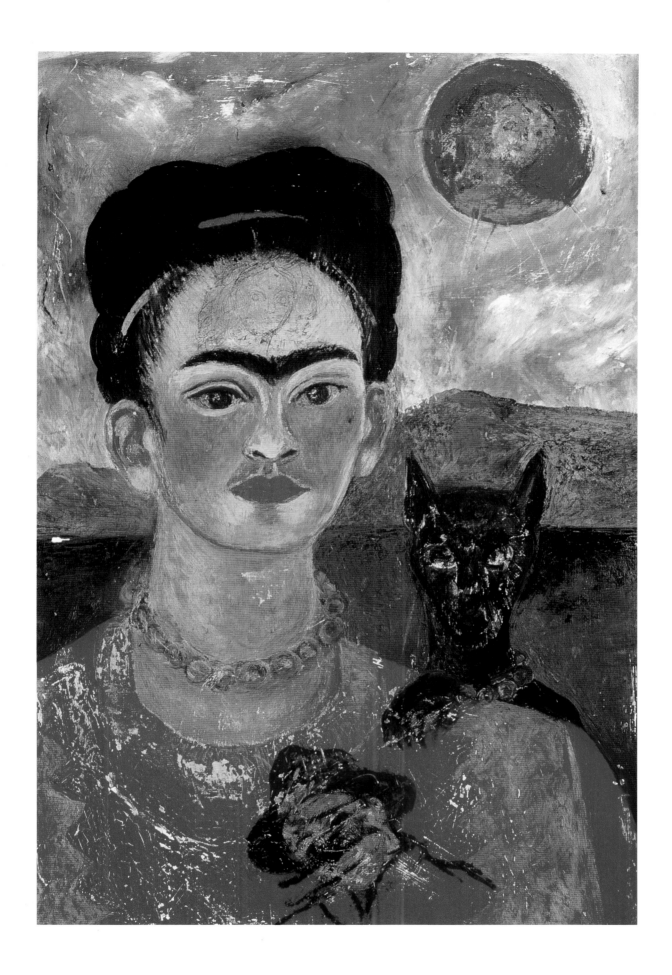

INDEX